GRAFITY'S WALL

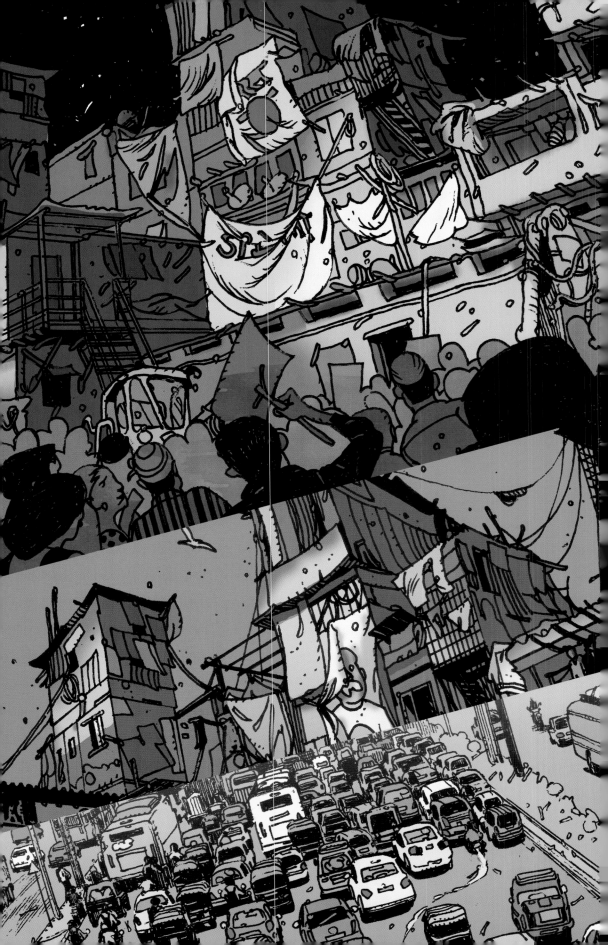

GRAFITY'S WALL

WRITTEN BY
RAM V

ART BY
ANAND RADHAKRISHNAN

LETTERED BY
ADITYA BIDIKAR

COLORS BY
**JASON WORDIE,
IRMA KNIVILA &
ANAND RADHAKRISHNAN**

ART ASSISTANCE
GIRISH MALAP

DARK HORSE BOOKS

PRESIDENT & PUBLISHER
MIKE RICHARDSON

EDITOR
KONNER KNUDSEN

DESIGNER
BRENNAN THOME

DIGITAL ART TECHNICIAN
JOSIE CHRISTENSEN

Originally published in the United Kingdom by Unbound
unbound.com

Published by Dark Horse Books
A division of Dark Horse Comics LLC.
10956 SE Main Street
Milwaukie, OR 97222

DarkHorse.com

First edition: March 2020
ISBN 978-1-50671-582-7

10 9 8 7 6 5 4 3 2 1
Printed in Korea

Neil Hankerson Executive Vice President · Tom Weddle Chief Financial Officer · Randy Stradley Vice President of Publishing · Nick McWhorter Chief Business Development Officer · Dale LaFountain Chief Information Officer · Matt Parkinson Vice President of Marketing · Cara Niece Vice President of Production and Scheduling · Mark Bernardi Vice President of Book Trade and Digital Sales · Ken Lizzi General Counsel · Dave Marshall Editor in Chief · Davey Estrada Editorial Director · Chris Warner Senior Books Editor · Cary Grazzini Director of Specialty Projects · Lia Ribacchi Art Director · Vanessa Todd-Holmes Director of Print Purchasing · Matt Dryer Director of Digital Art and Prepress · Michael Gombos Senior Director of Licensed Publications · Kari Yadro Director of Custom Programs · Kari Torson Director of International Licensing · Sean Brice Director of Trade Sales

Library of Congress Cataloging-in-Publication Data

Names: V, Ram, writer. | Radhakrishnan, Anand, artist, colourist. |
 Bidikar, Aditya, letterer. | Wordie, Jason (Colorist), colourist. |
 Kniivila, Irma, colourist.
Title: Grafity's wall / written by Ram V ; art by Anand Radhakrishnan ;
 lettered by Aditya Bidikar ; colors by Jason Wordie, Irma Kniivila &
 Anand Radhakrishnan.
Description: Expanded edition. | Milwaukie, OR : Dark Horse Comics, 2020. |
 Summary: "Four kids in Mumbai are brought together by circumstances at a
 broken down wall--one that will become a canvas for the picture of their
 lives in a place that both inspires and oppresses, indiscriminately and
 in equal measure"-- Provided by publisher.
Identifiers: LCCN 2019044096 | ISBN 9781506714288 (hardcover)
Subjects: LCSH: Graffiti--Comic books, strips, etc. | Mumbai (India)--Comic
 books, strips, etc. | Graphic novels.
Classification: LCC PN6790.I43 V25 2020 | DDC 741.5/954--dc23
LC record available at https://lccn.loc.gov/2019044096

This book is dedicated to **childhood friends**,
Without whom I would not have the reckless courage to
Continue being a child after all these years.

Tejas, **Varun**, **Preeti**, **Rajiv**—for insisting on
Being friends with the class nerd.

The **Ambikars**, **Sangeetha**, **Veena**, **Vaishali,** and **Niranjan** for
Teaching me what it's like to live and grow across cultures.

To new friends—the **crew at White Noise Studios**.
Gems, all of you.

To **Lizzie Kaye**, my editor, champion and a woman of infinite
patience and encouragement.

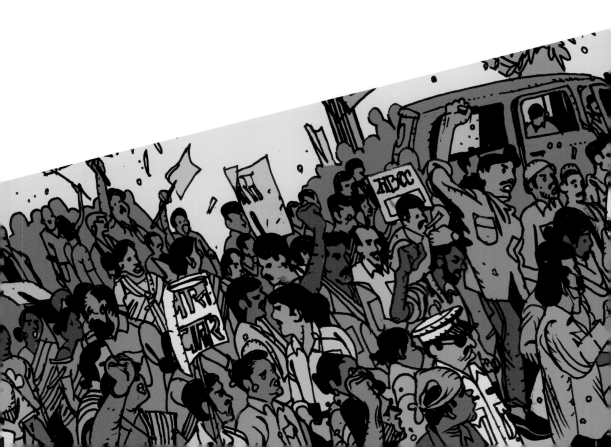

This is startling work. It's striking, its palette bold, both in literary and visual terms. It's work that both doesn't need an introduction while being entirely deserving of one...

But first, a confession.

I have a certain word blindness, especially for nouns. As a child, I confused the word "Chameleon" with "Leviathan", which adds a certain apocalyptic bent the Culture Club song "Karma Chameleon." One of my first jobs at Marvel was a one-off issue about X-men villain Sabretooth, where I handed in a script entitled "Saberwulf." It was only when actually talking to a friend about his fascinating, serious, Lynchian RPG about lost memories in Sin City, that I realised it was actually called "Alas Vegas" and not, as my brain had decided, "Alan Vegas."

As such, despite having read this in a previous edition, it was only when writing this introduction that I realised the book was called *Grafity's Wall* and not, as I had previously thought, *Gravity's Wall*.

This is despite a character in the book being called Grafity. I just thought he, *the graffiti artist*, was called Gravity.

I have a theory why I thought this, bar my brain just doing its own thing. I presume Ram is indulging in writing cleverness, and approaching truth tangentially, which is what encouraged me to make the leap.

In a real way, this *is* a book about gravity.

Gravity does have its upside. It allows you to orientate yourself. The eponymous wall is a force of gravity, with these four young people in its orbit, always returning there. These satellite people, spinning around it, yearning to escape.

How can they try to do that? Art. Can the power of their ambitions and skill find the power to propel themselves free? Often it seems impossible, and the bleakness creeps in. Except, all the while, the book is a testament by the brilliance of its existence to the fact that dreaming is not impossible. There's always hope. That there's always hope is what gets you.

This is a classic arc of a coming of age story. I recognise these urges, though my time was spent wearing Hawaiian polyester T-shirts while serving in a bar rather than trying to avoid being beating up by my aggressive dealer. This is very human and intensely recognisable to anyone who has ever been young and wanted more.

It is also very Mumbai. I'm presuming that. I've never been there, but with the life in these pages, I can only assume that this is what it feels like, because if it wasn't speaking to some truth, it wouldn't hit as hard or be as vibrant as it is.

I often say, "A city is a coral reef," and every page of Anand RK's work here screams that he agrees. There are so many crowd scenes that my hand aches in sympathy, but each chosen to capture and enhance the required mood. Moments when it becomes pop-art. Moments when it turns psychedelic. Still moments at night, with the heat throbbing from the panel. Slice of life, but in the tradition of Eddie Campbell where it is about life as felt in all its drama rather than life reduced, life as surrender, life as no life at all. Bidikar is one of my favourite letterers of a new generation, and the highest compliment is how they find a way to integrate seamlessly with work as characterful and idiosyncratic as this. It works so well that, until I read the credits, I had presumed Anand RK self-lettered.

There are fundamentally four short stories here, but the telling twists, between moments which work in a traditional narrative mode, and moments which are all about the sense of place. The panels move, from aspect to aspect across the city, and it pulses before your eyes.

I have no idea how it was written. I can only hope that more people write this way.

This is a comics vision of a city, of friends, of life.

There is a line early on where Grafity takes a moment, and talks about the lingering effect of his art, even if it's been painted over.

"You can't unsee it."

That, Grafity. *That*.

Grafity's Wall: you can't unsee it.

KIERON GILLEN, LONDON.

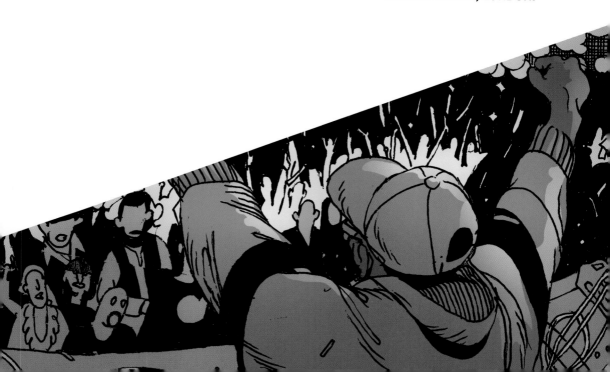

CHAPTER 1

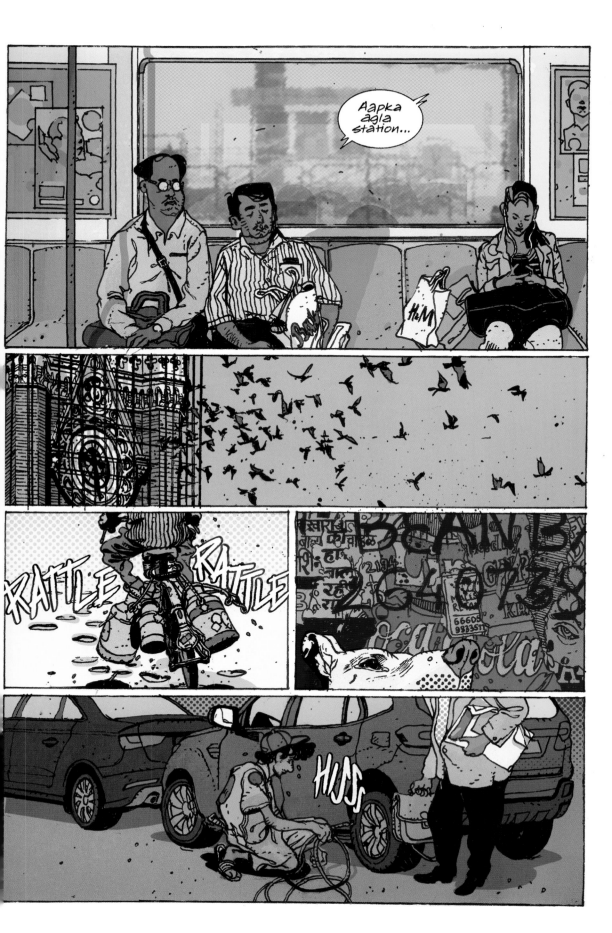

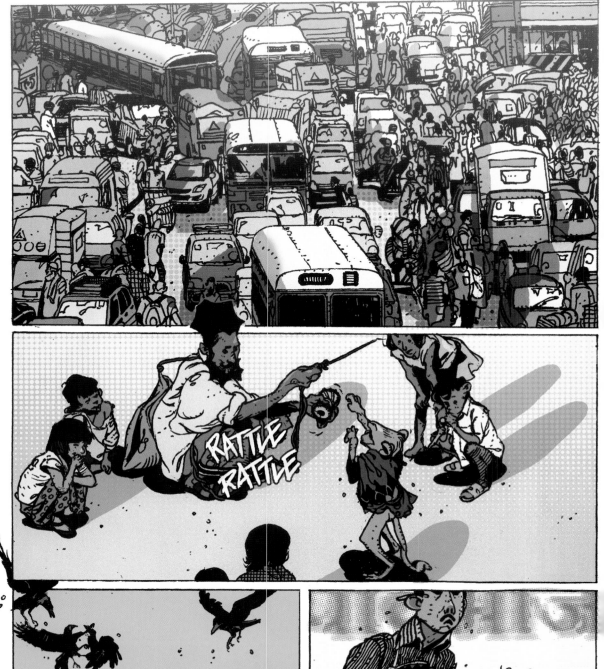

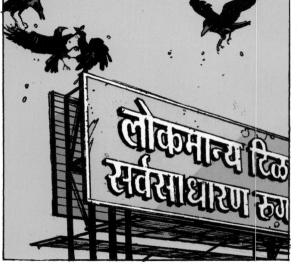

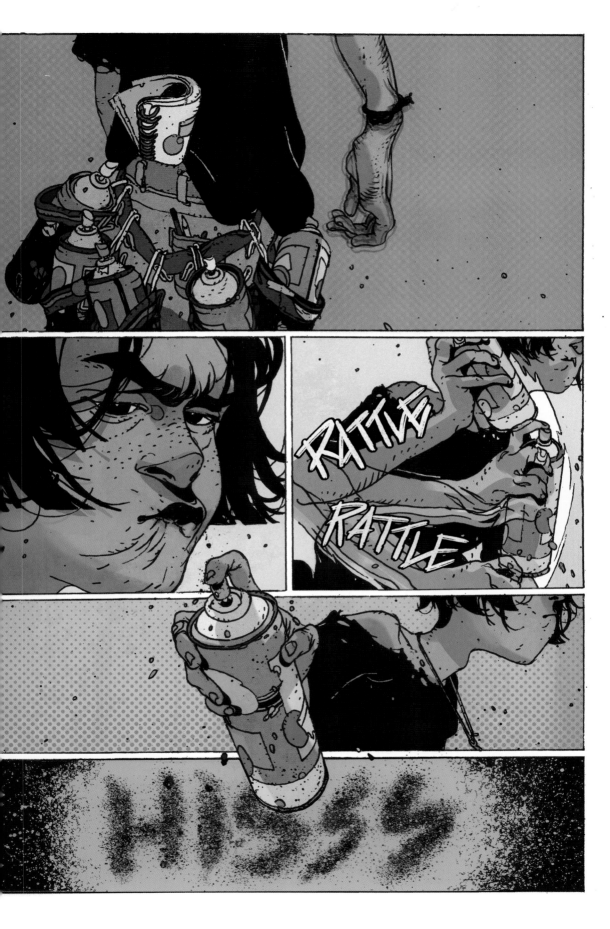

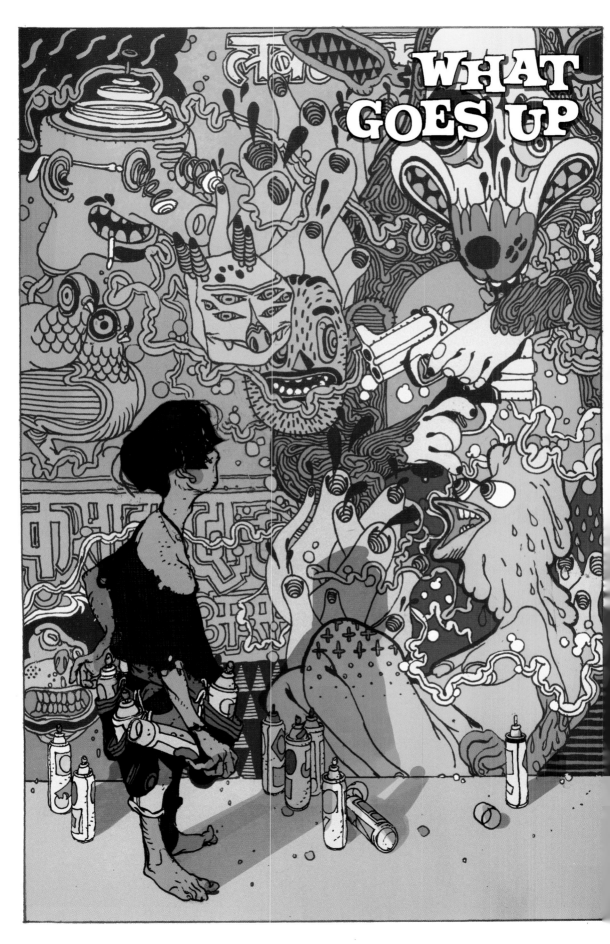

WHAT GOES UP

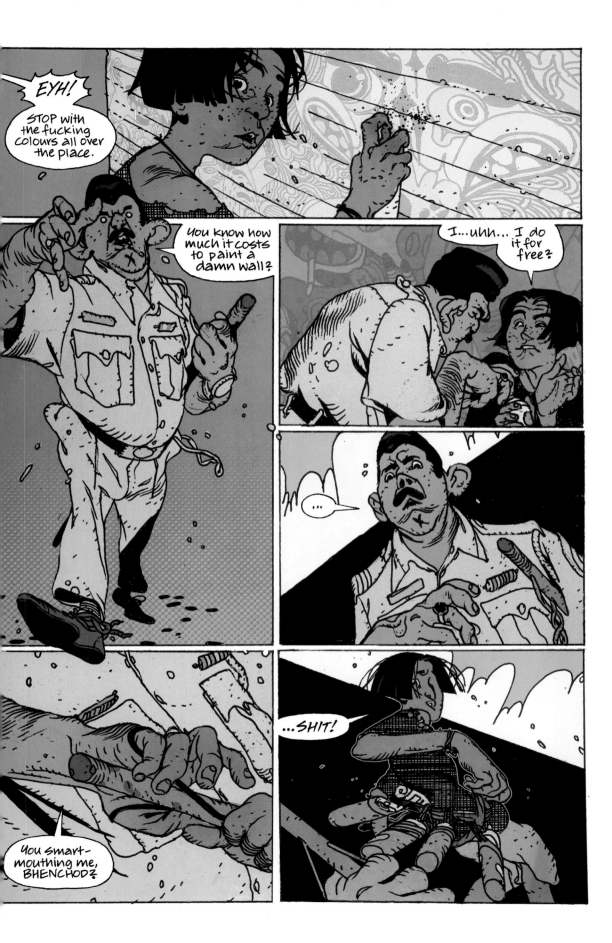

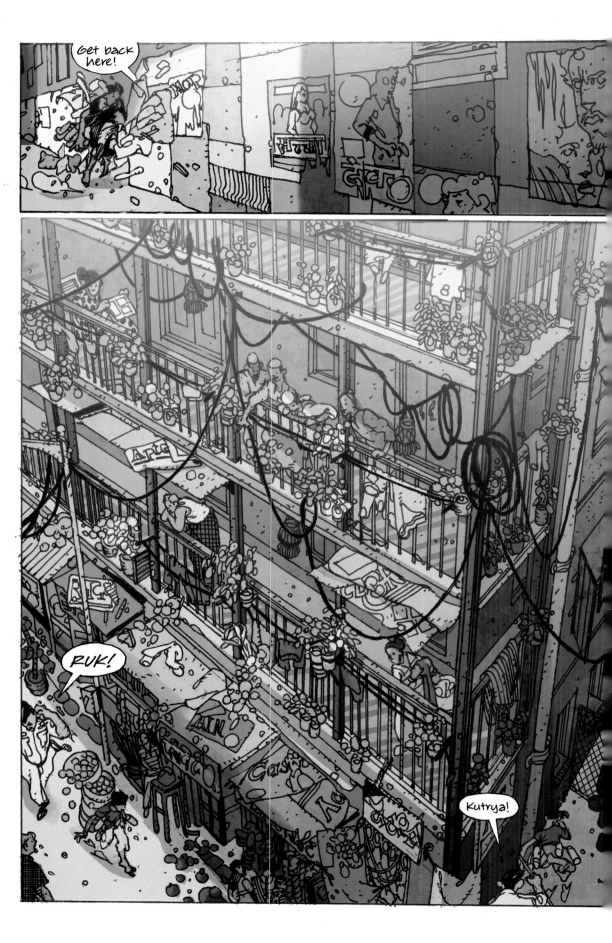

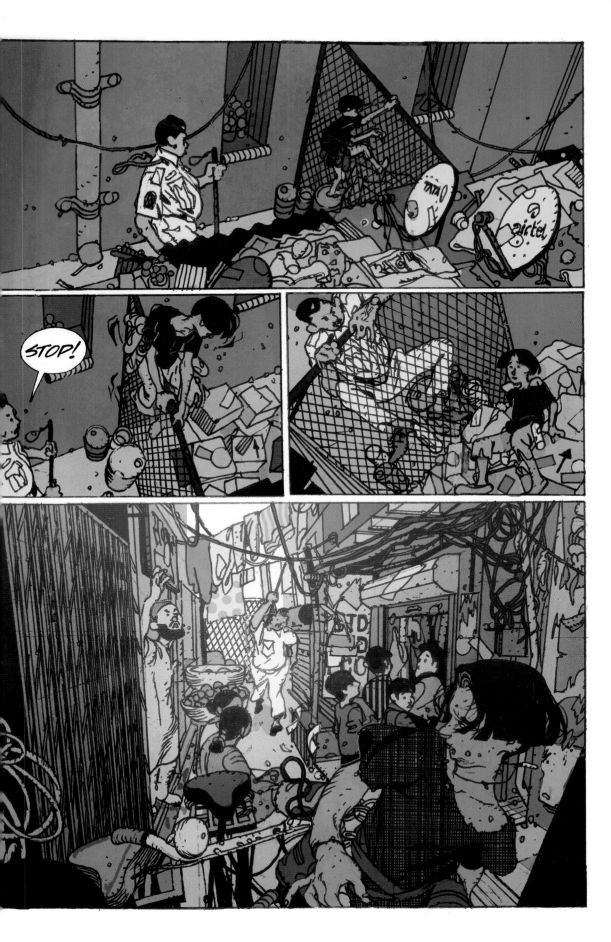

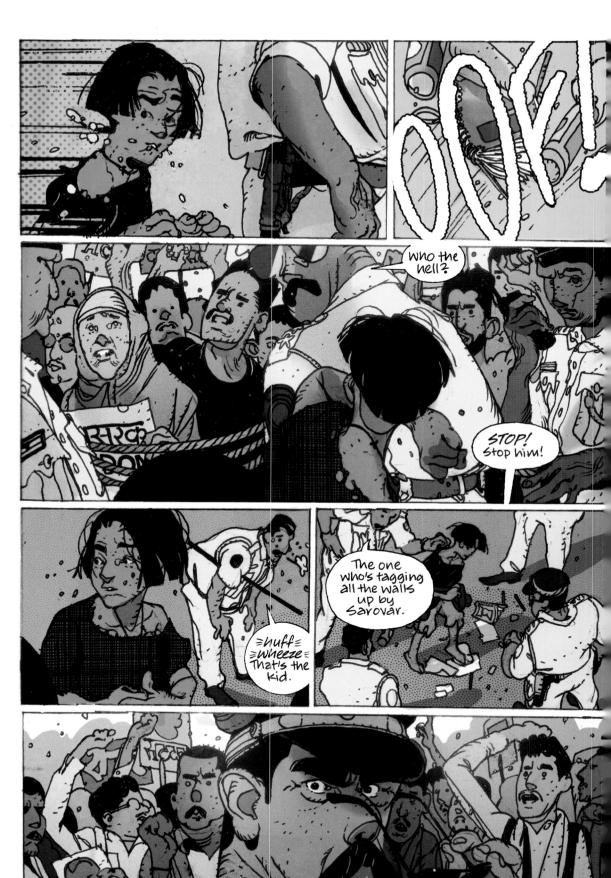

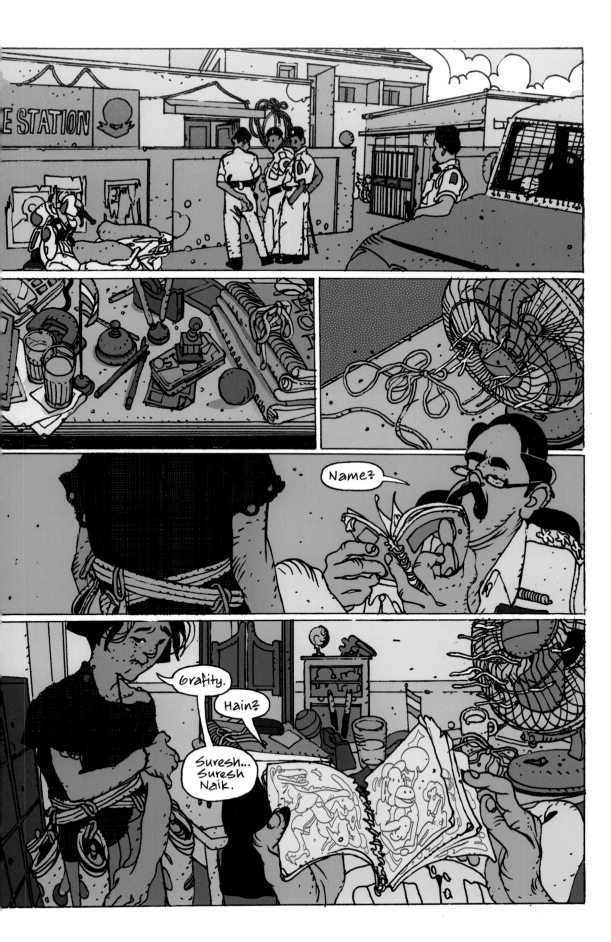

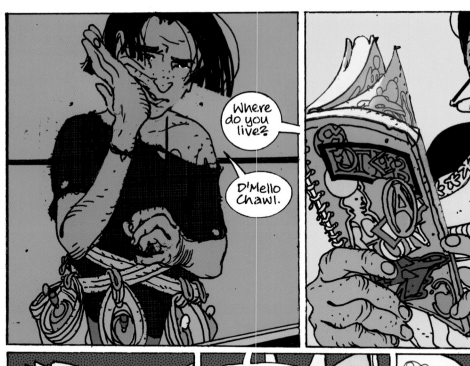

Where do you live?

D'Mello Chawl.

Ouh, D'Mello.

I'm not surprised.

And this? What the fuck is this?

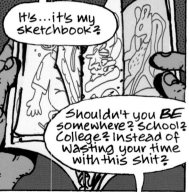

It's...it's my sketchbook?

Shouldn't you **BE** somewhere? School? College? Instead of wasting your time with this shit?

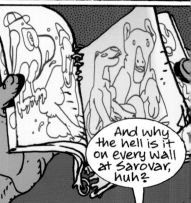

And why the hell is it on every wall at Sarovar, huh?

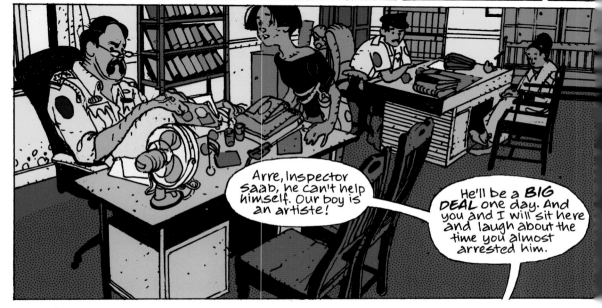

Arre, Inspector Saab, he can't help himself. Our boy is an artiste!

He'll be a **BIG DEAL** one day. And you and I will sit here and laugh about the time you almost arrested him.

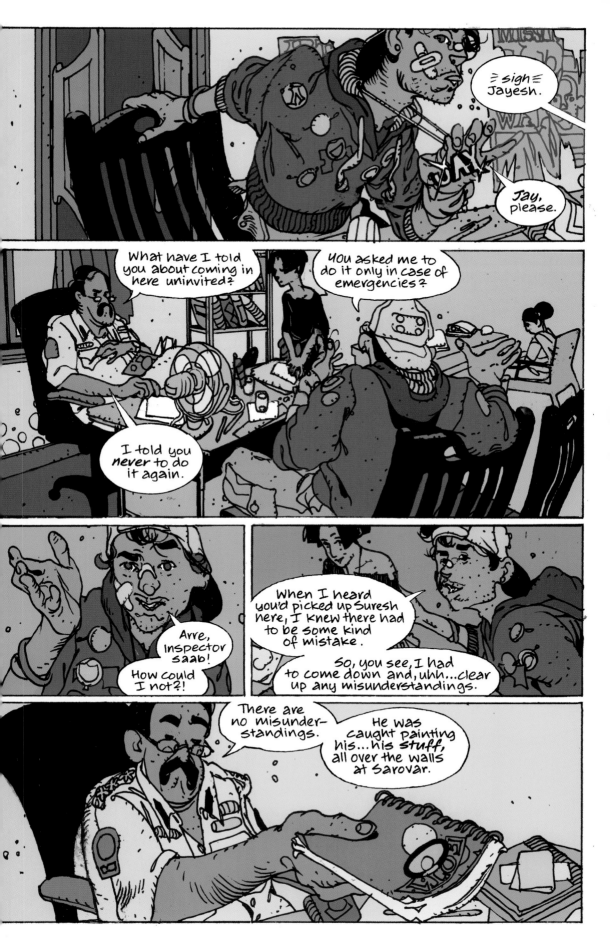

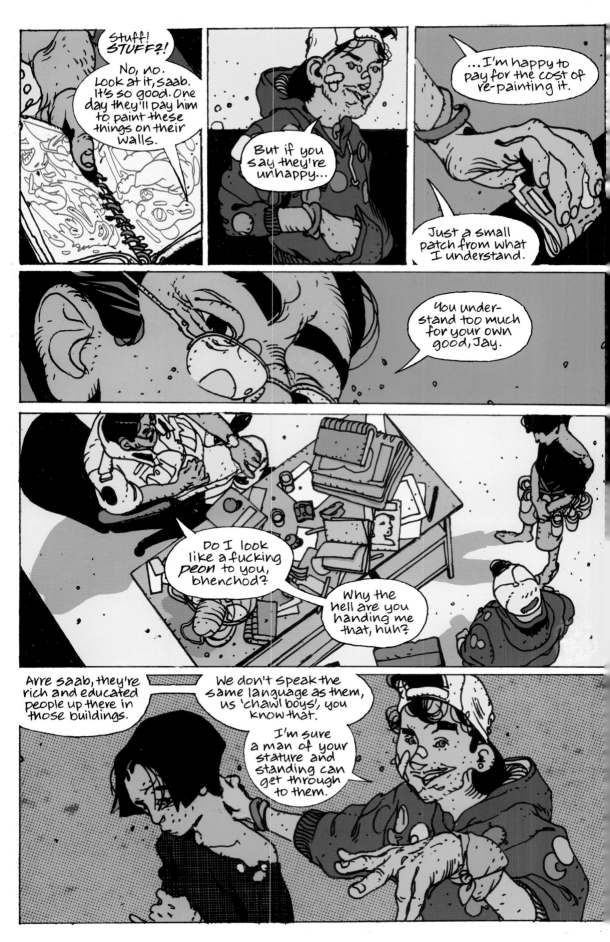

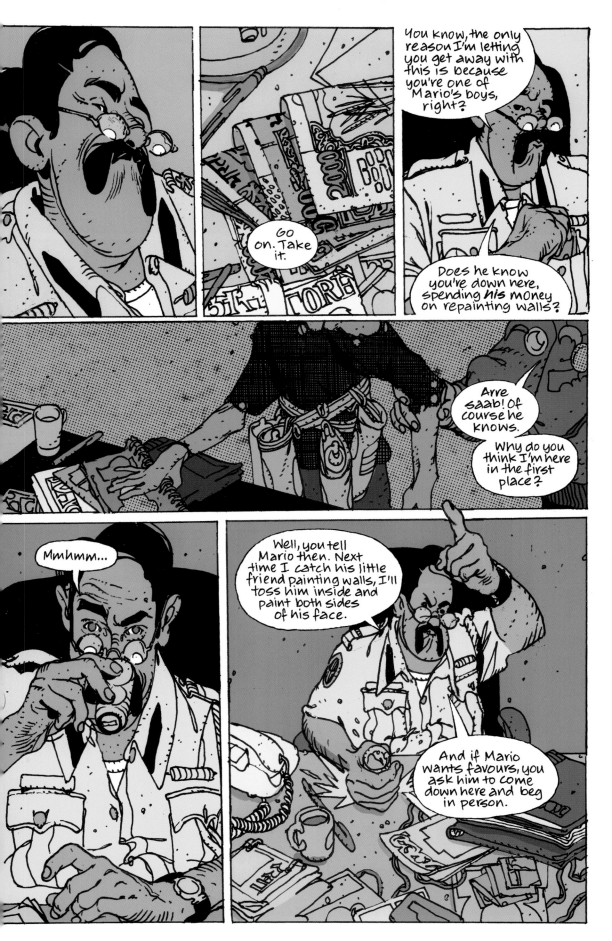

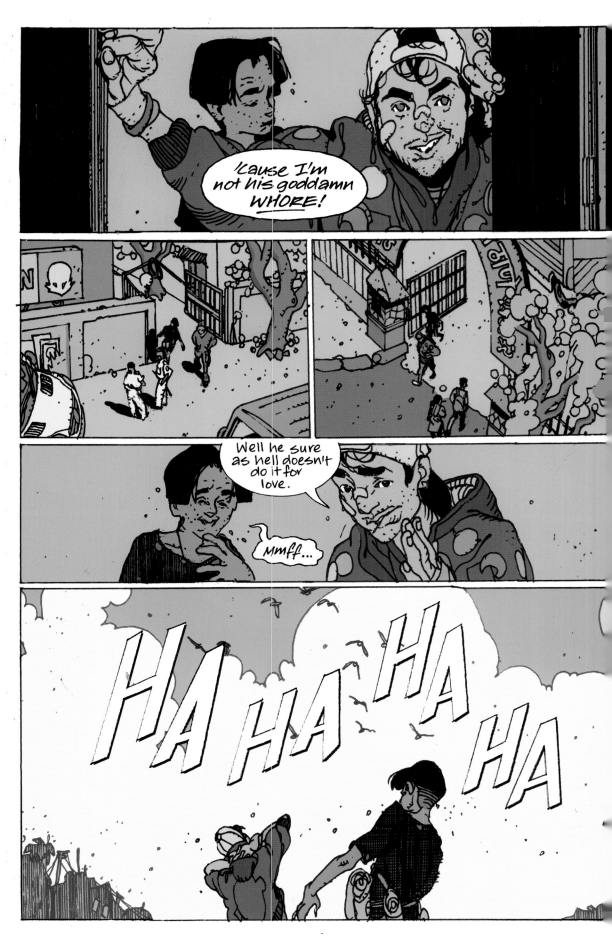

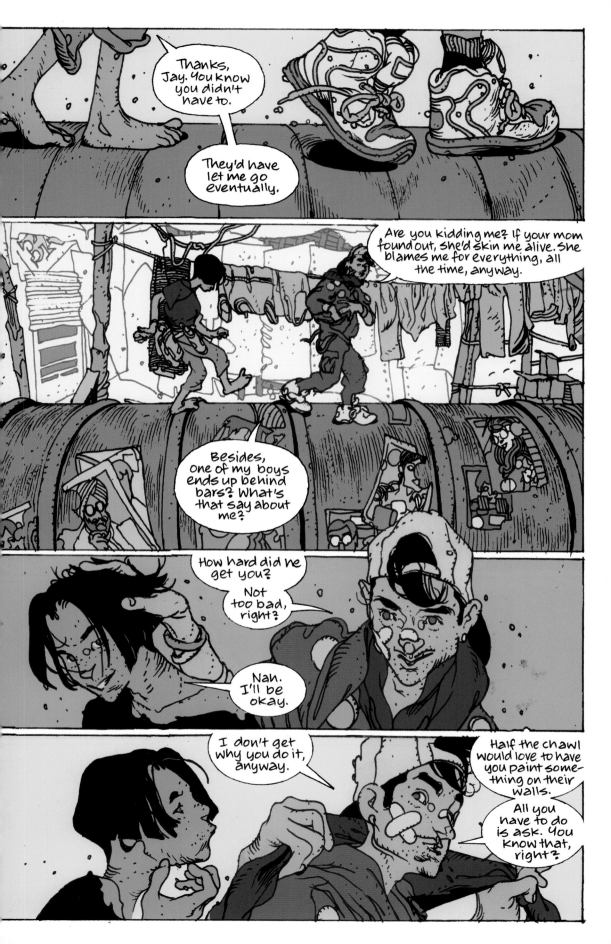

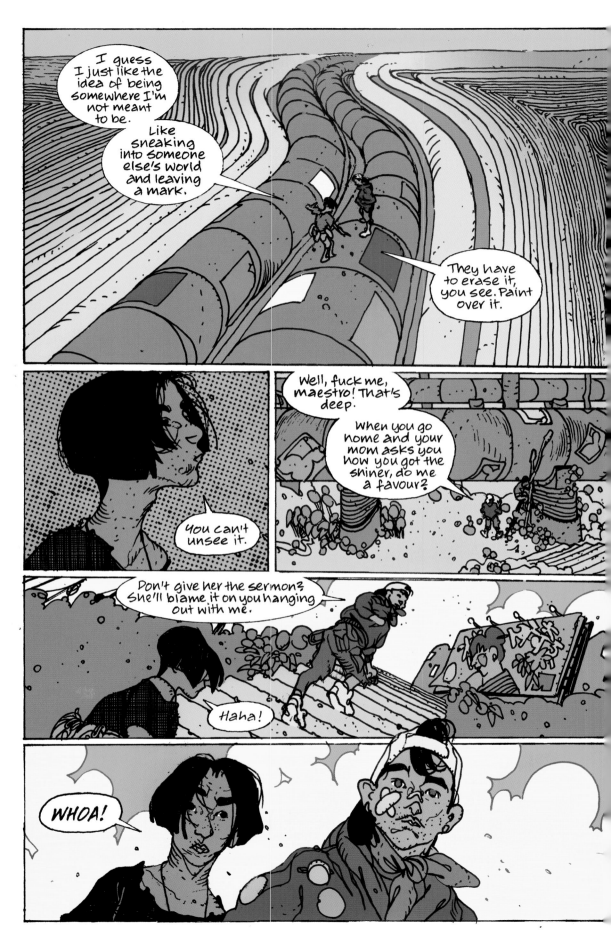

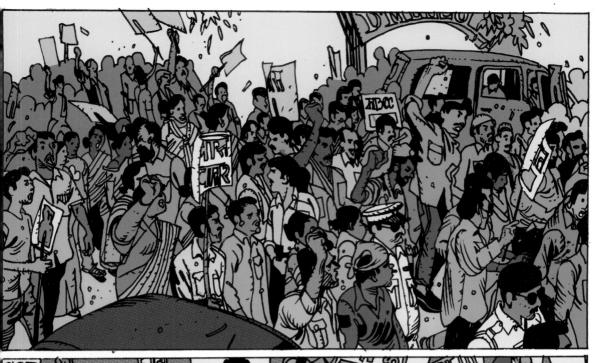

What's with all the people?

You serious? You haven't heard?

Heard what?

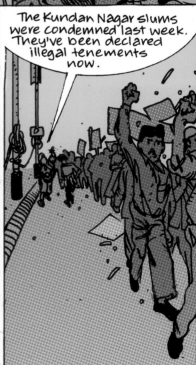

The Kundan Nagar slums were condemned last week. They've been declared illegal tenements now.

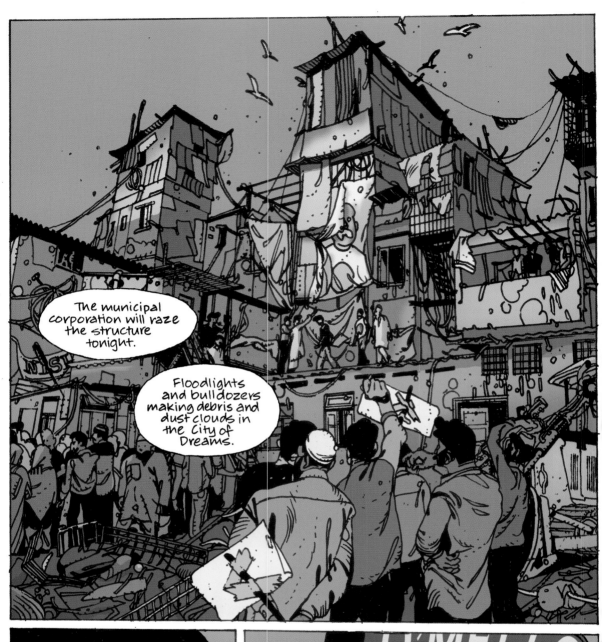

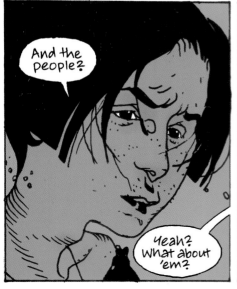

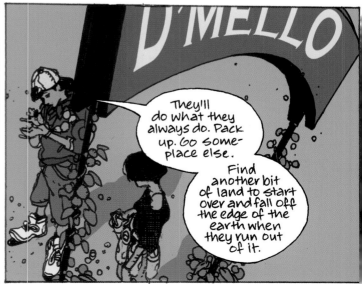

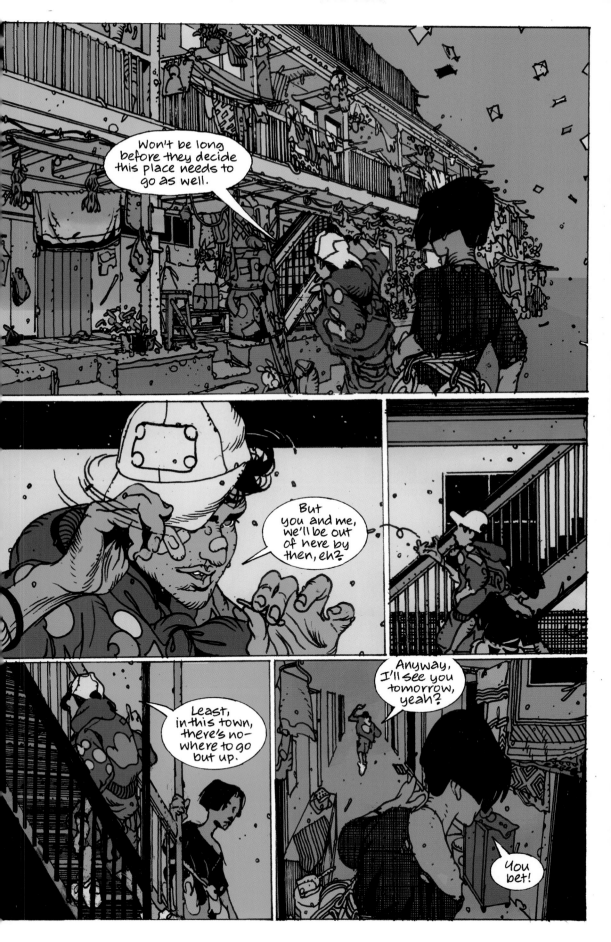

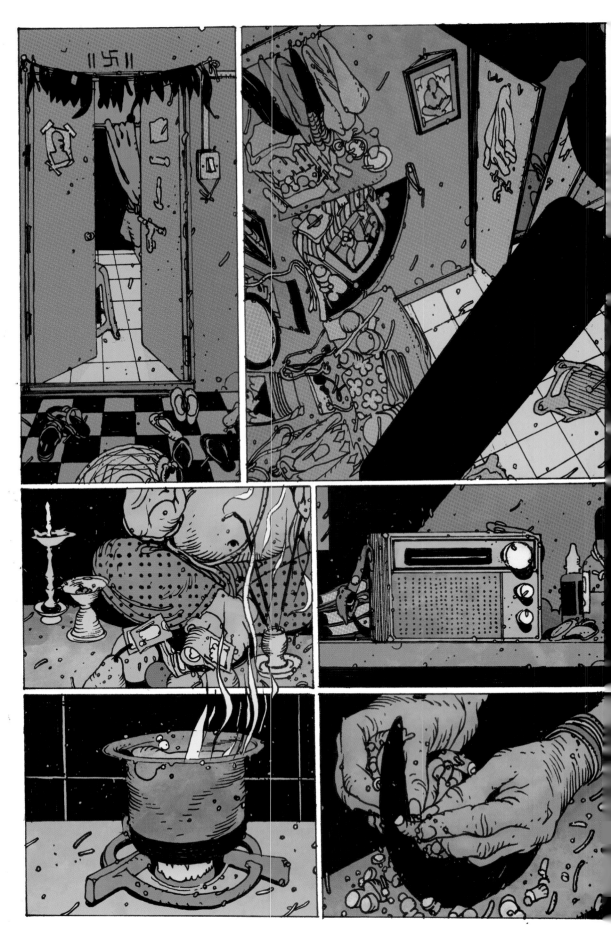

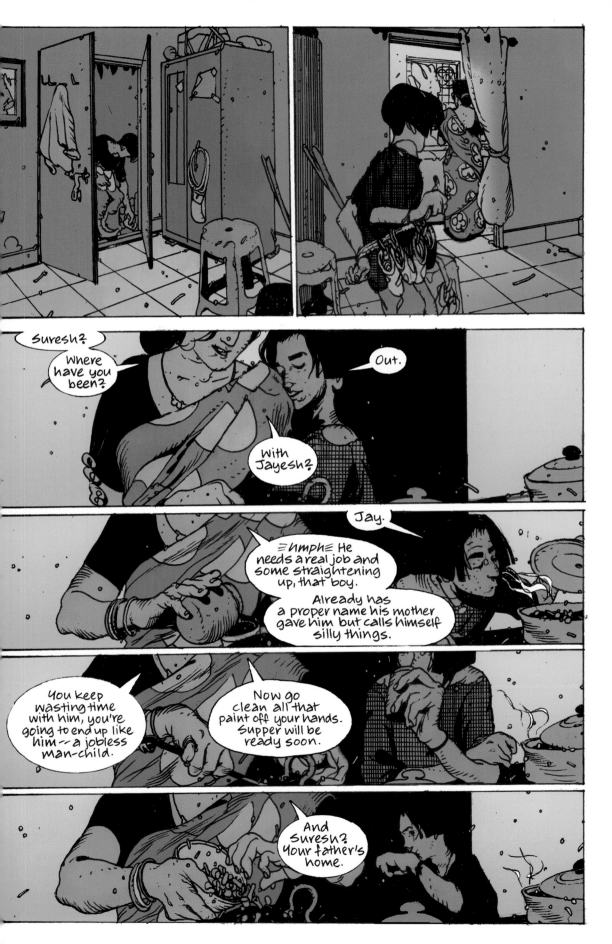

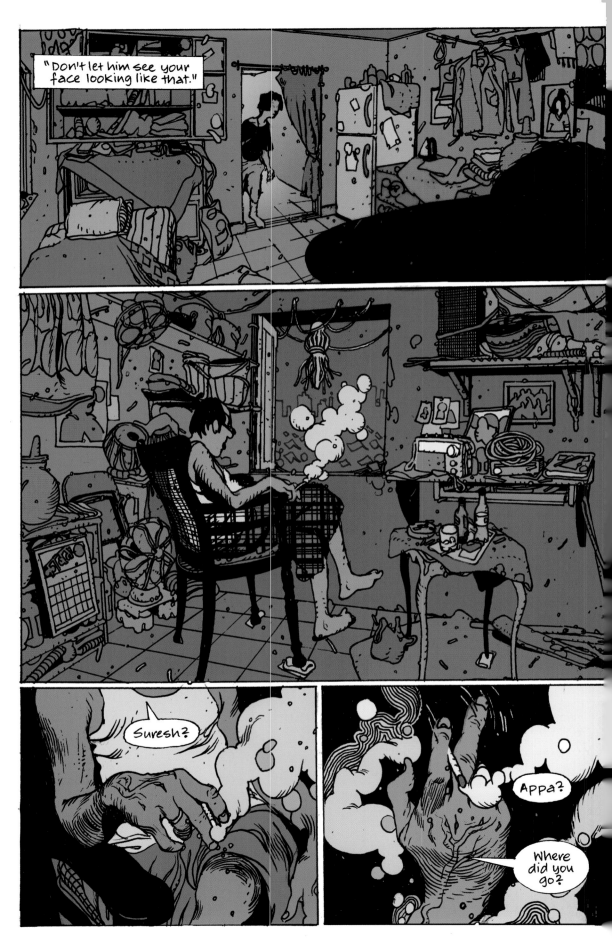

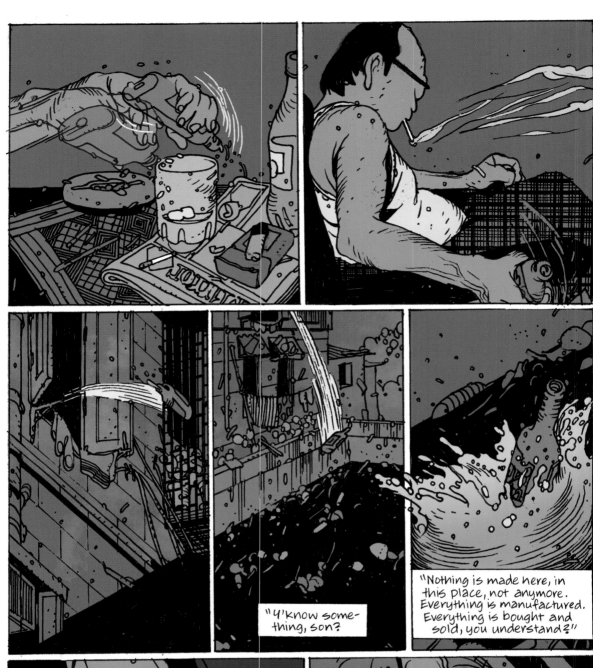

"Y'know something, son?"

"Nothing is made here, in this place, not anymore. Everything is manufactured. Everything is bought and sold, you understand?"

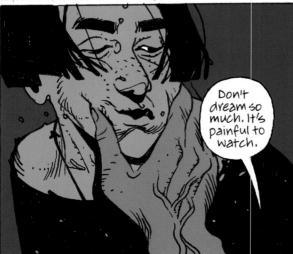

Don't dream so much. It's painful to watch.

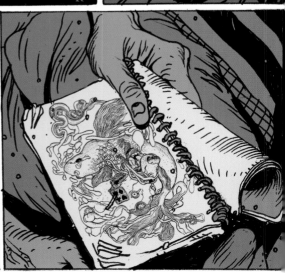

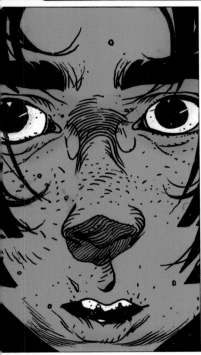

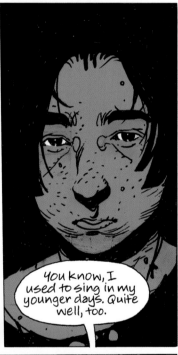

You know, I used to sing in my younger days. Quite well, too.

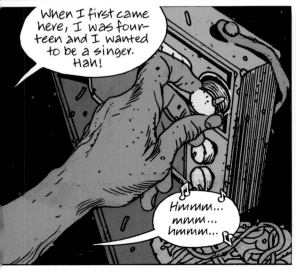

When I first came here, I was fourteen and I wanted to be a singer. Hah!

Hmmm... mmm... hmmm...

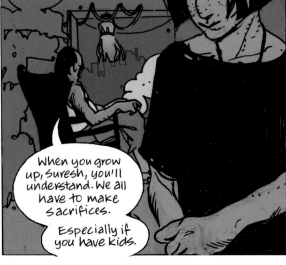

When you grow up, Suresh, you'll understand. We all have to make sacrifices.

Especially if you have kids.

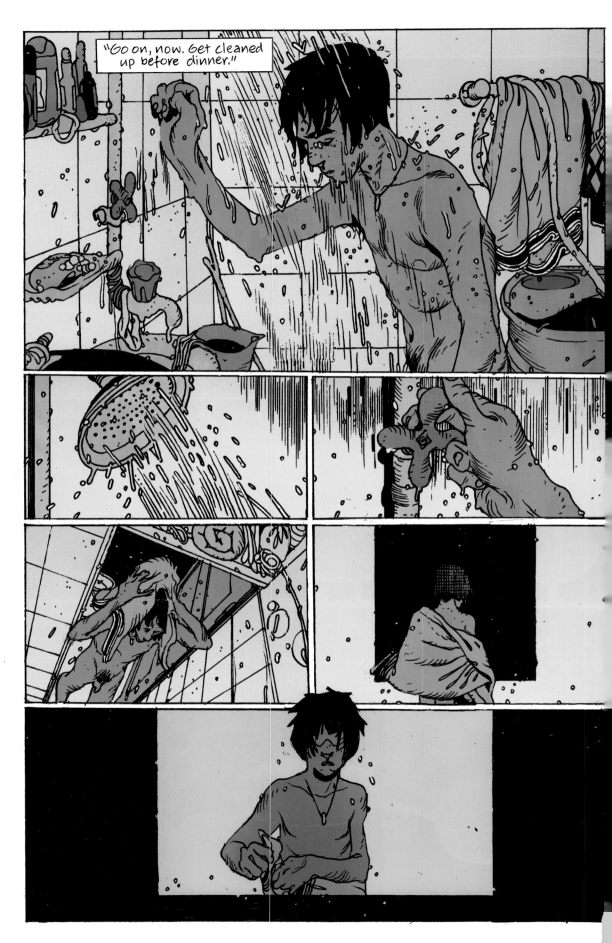

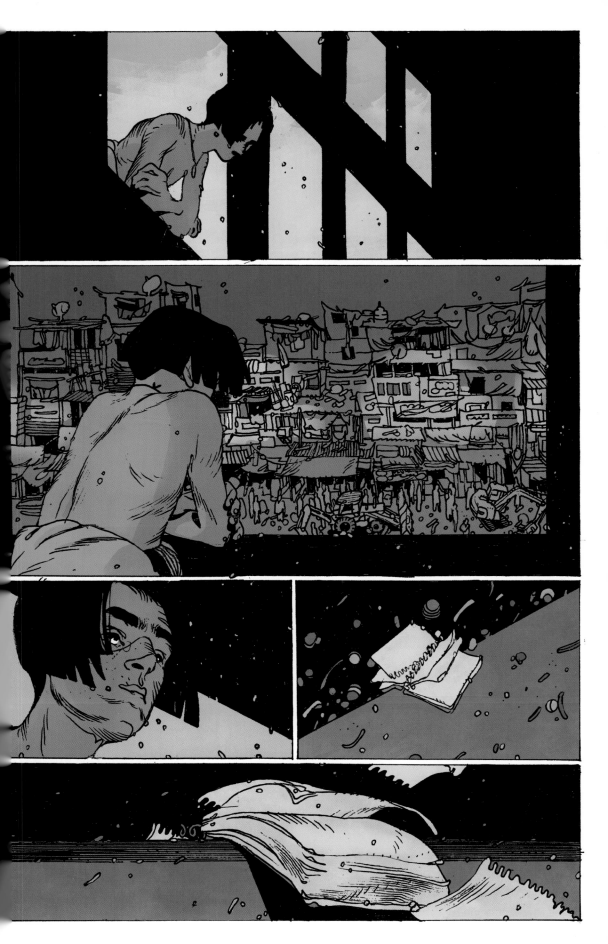

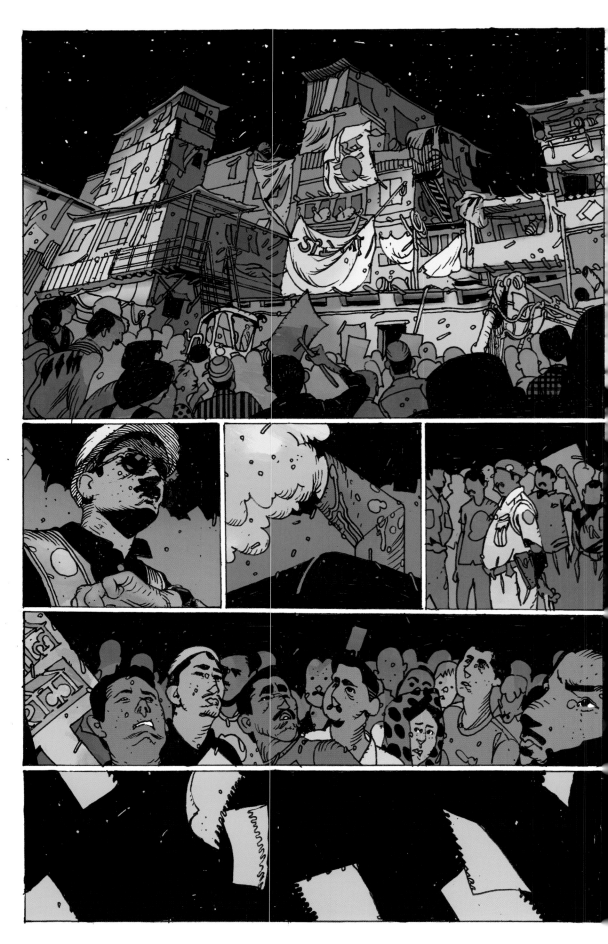

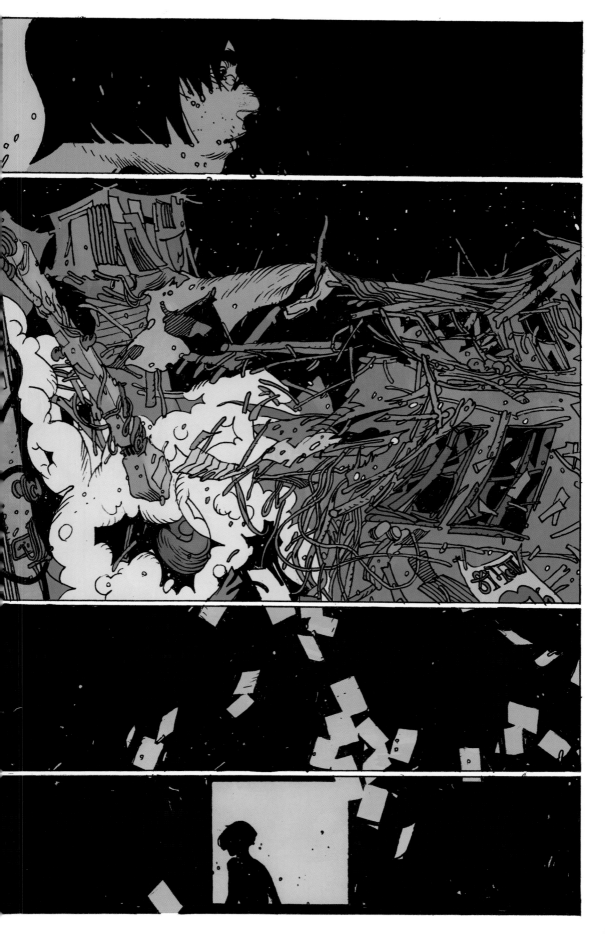

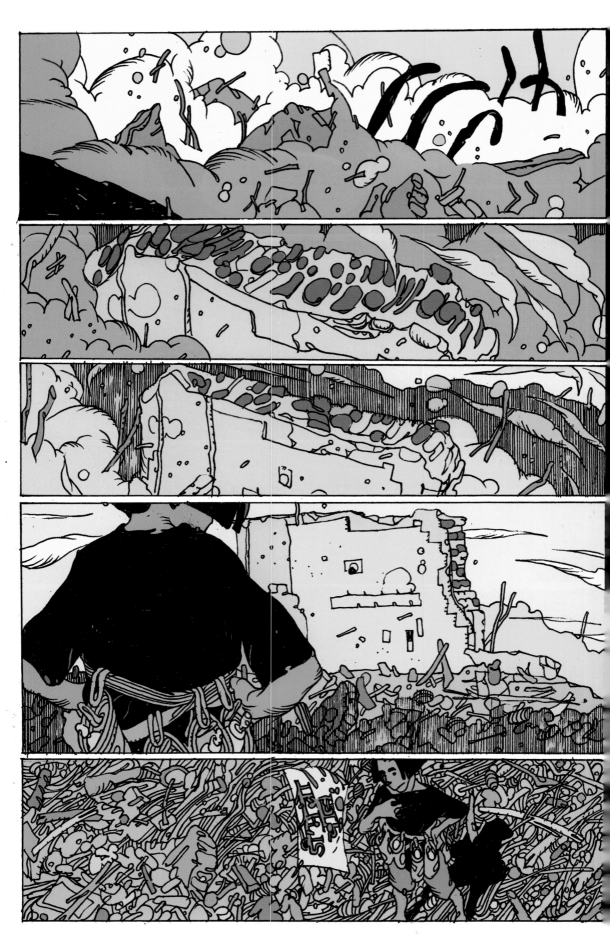

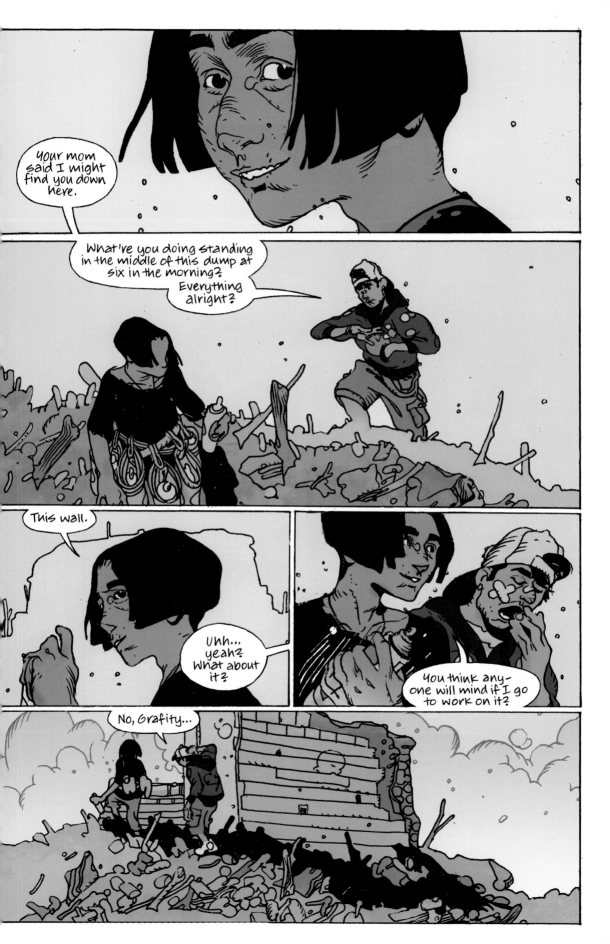

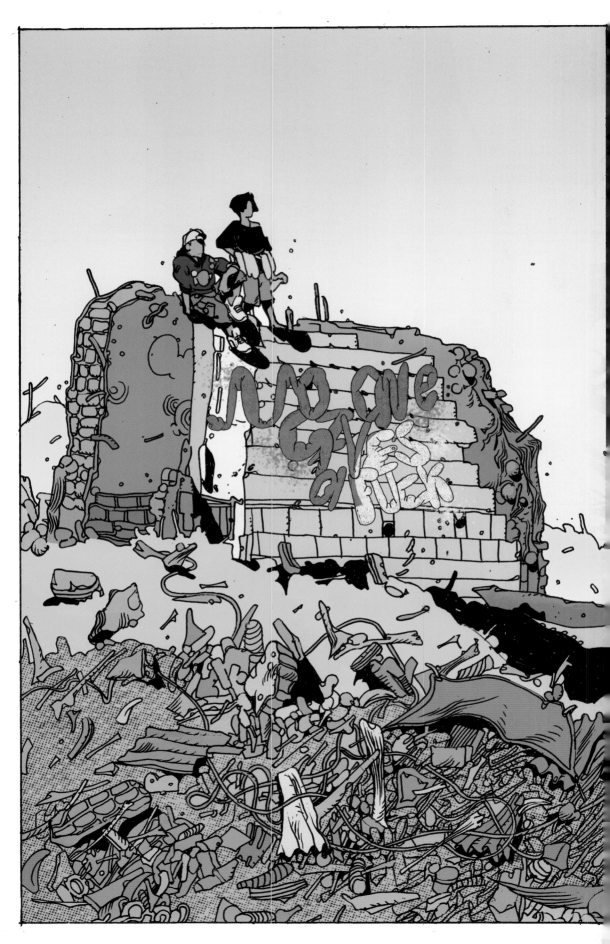

CHAPTER 2

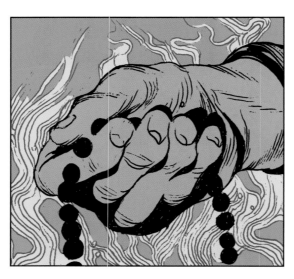

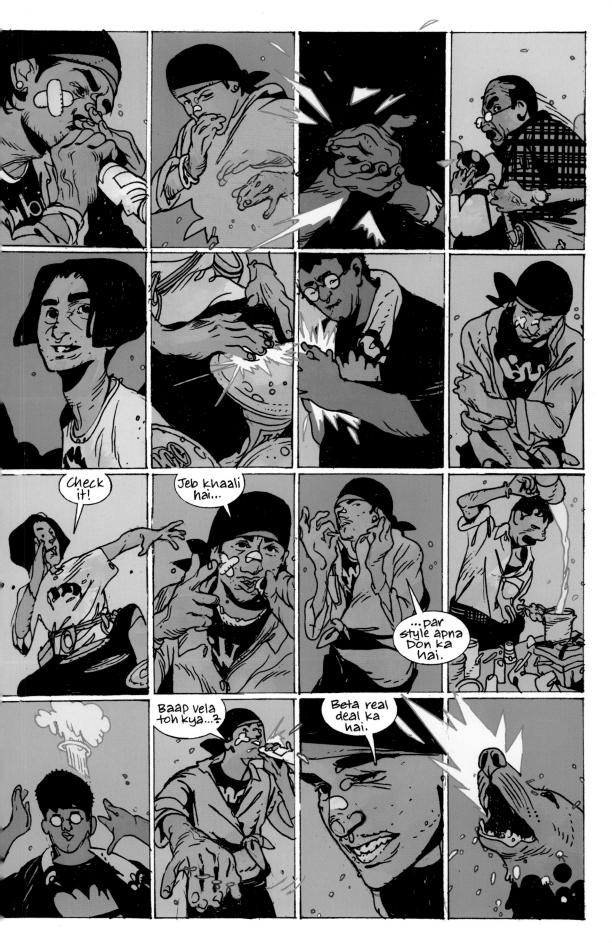

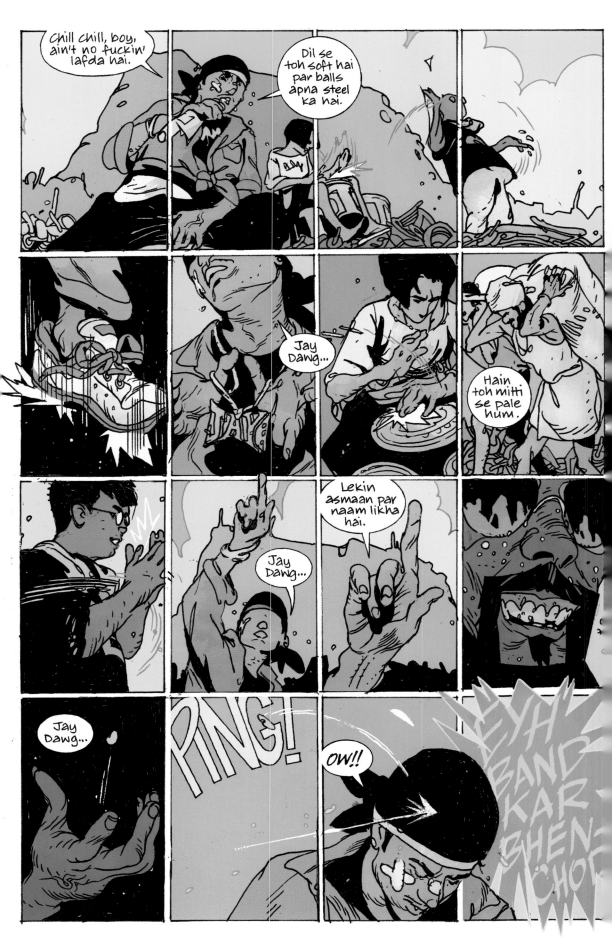

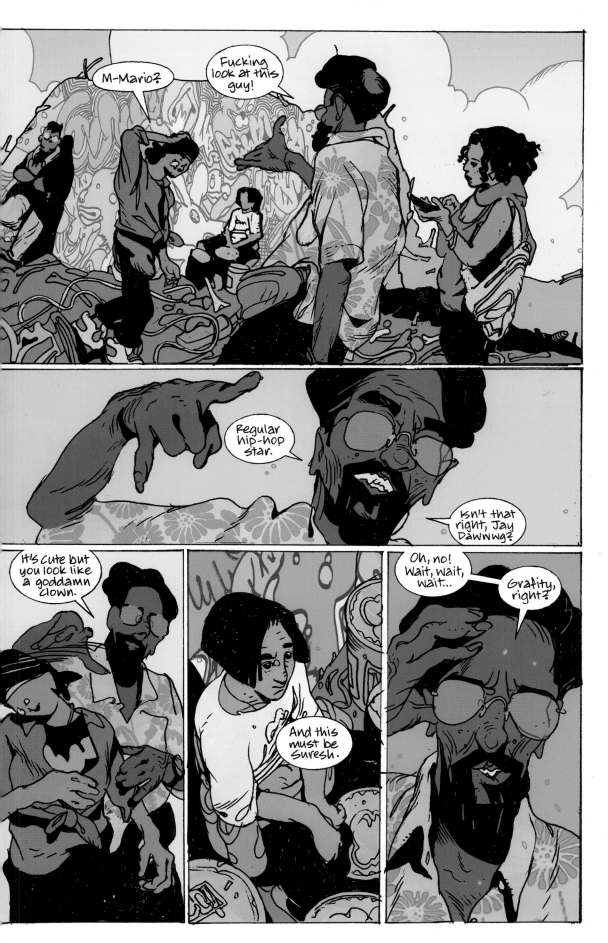

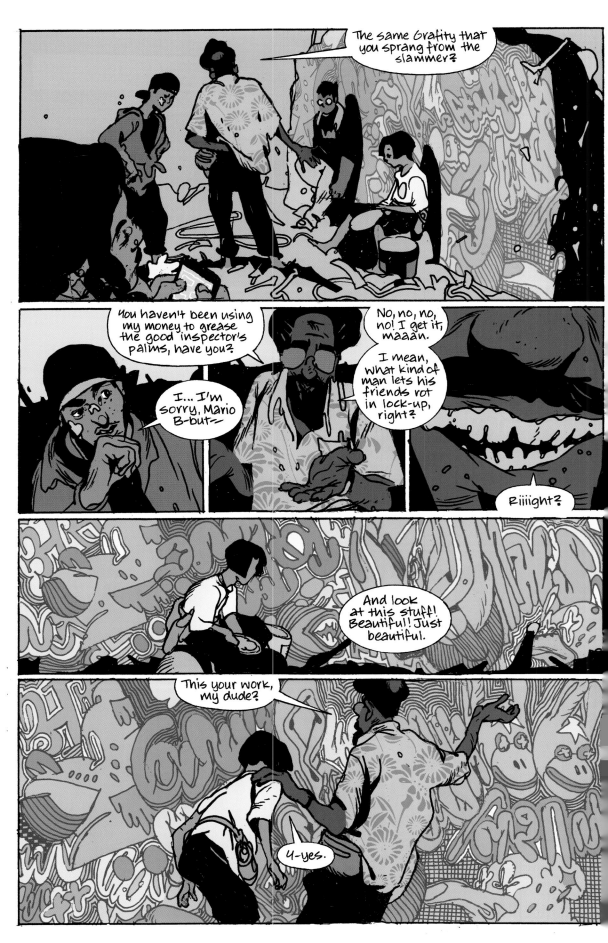

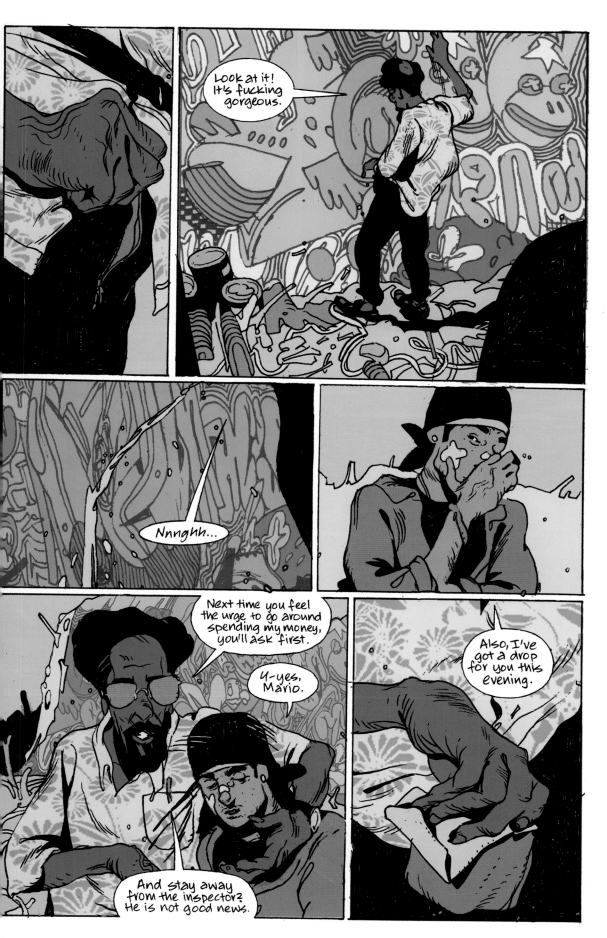

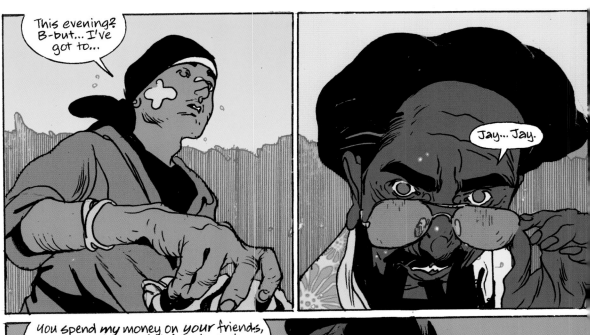

This evening? B-but... I've got to...

Jay... Jay.

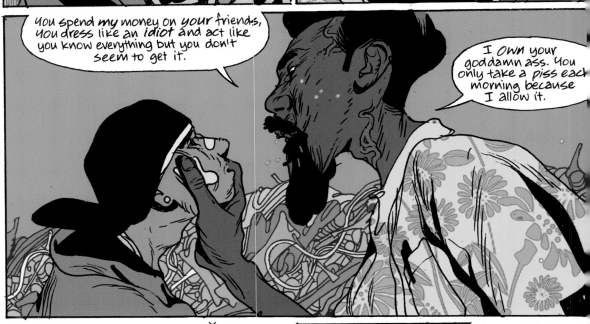

You spend *my* money on *your* friends, you dress like an *idiot* and act like you know everything but you don't seem to get it.

I *own* your goddamn ass. You only take a *piss* each morning because I allow it.

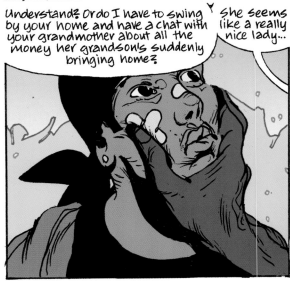

Understand? Or do I have to swing by your home and have a chat with your grandmother about all the money her grandson's suddenly bringing home?

She seems like a really nice lady...

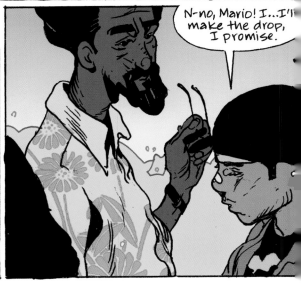

N-no, Mario! I...I'll make the drop, I promise.

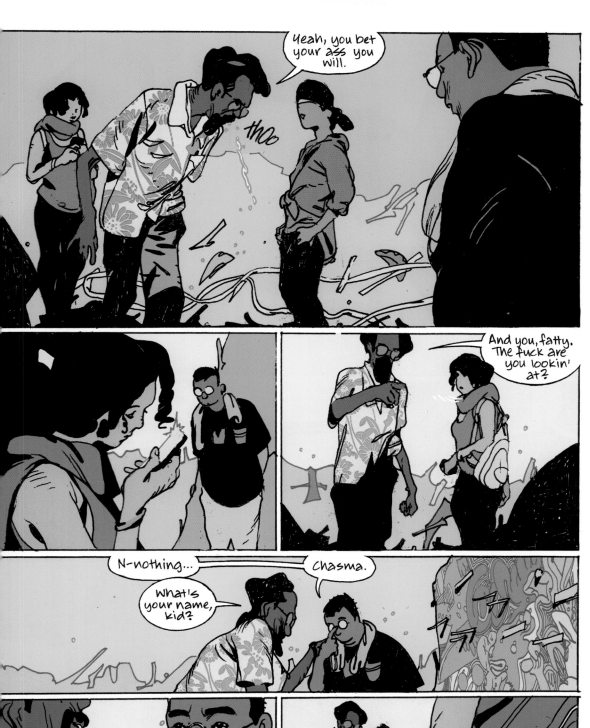
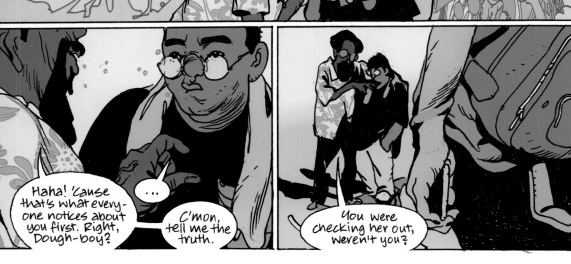

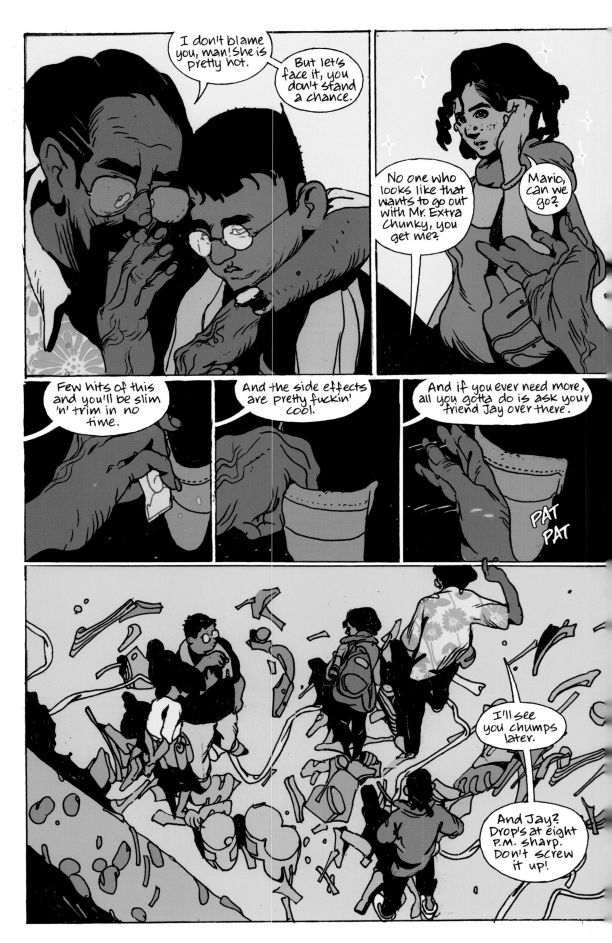

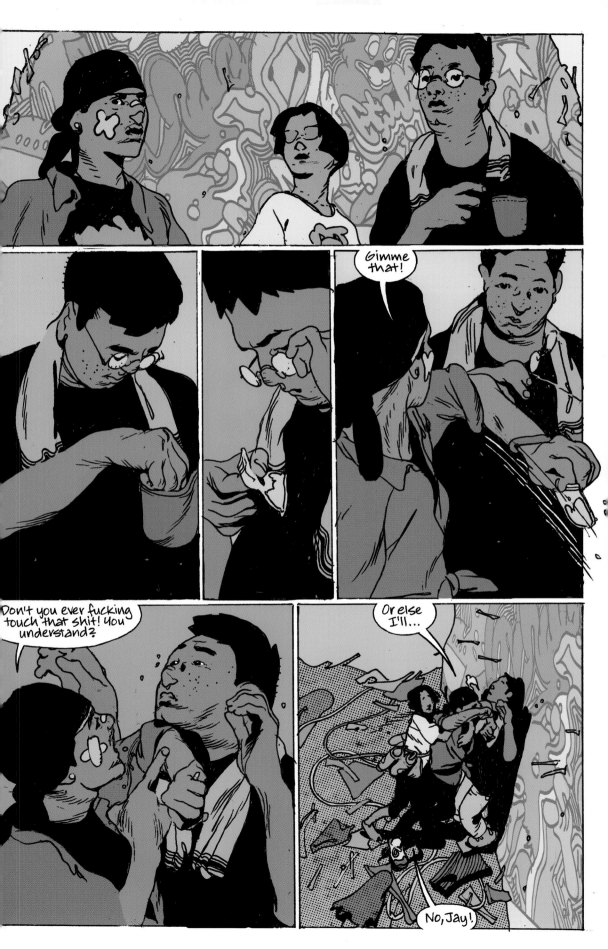

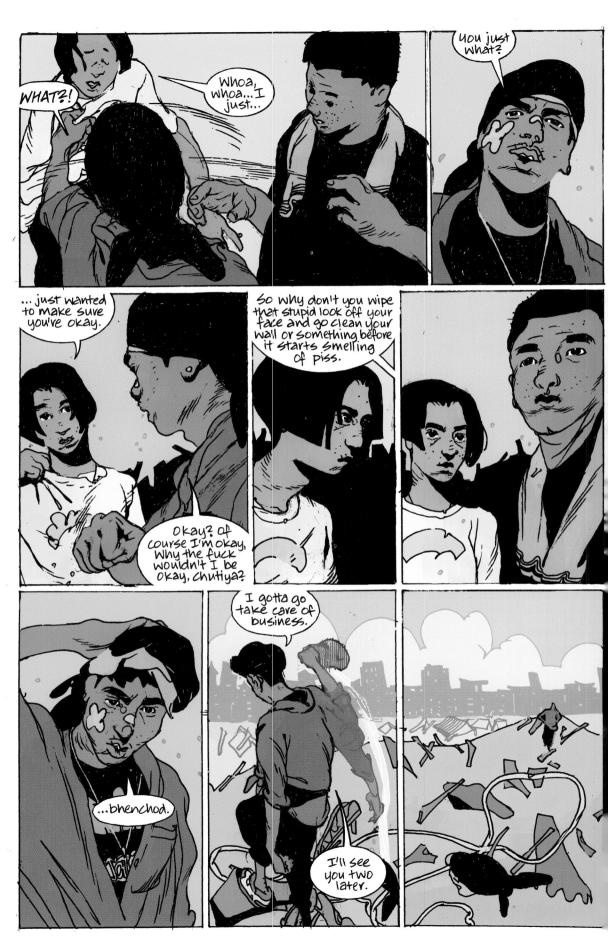

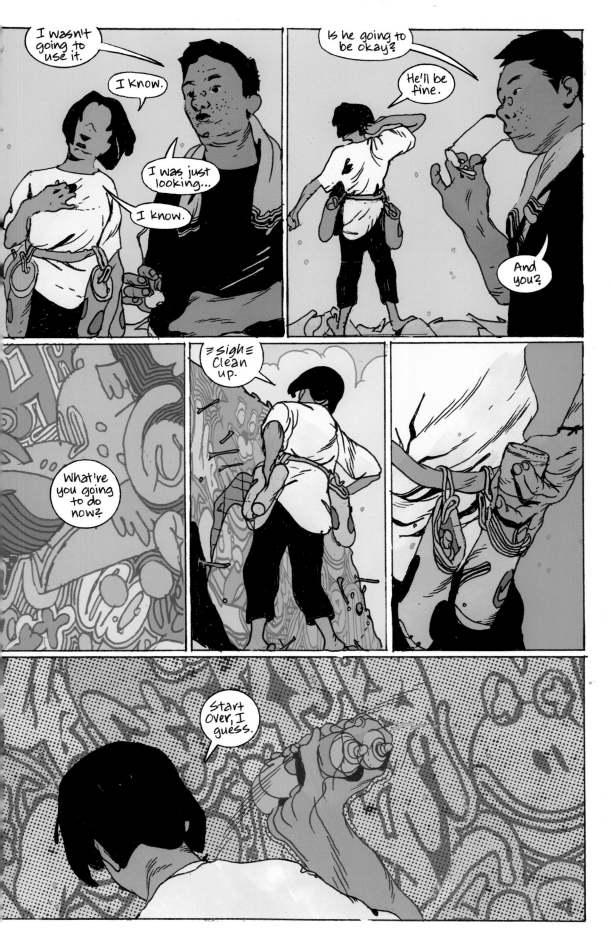

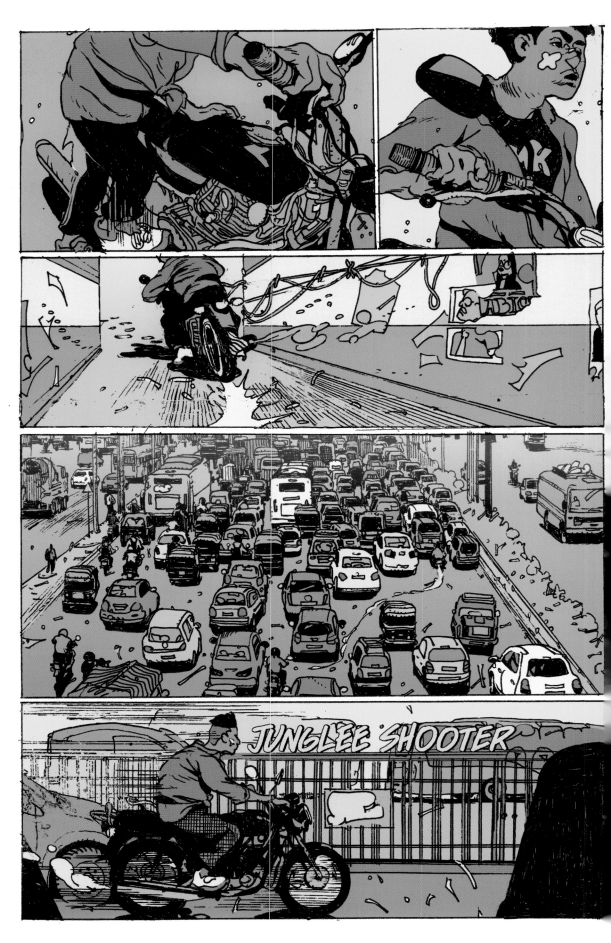

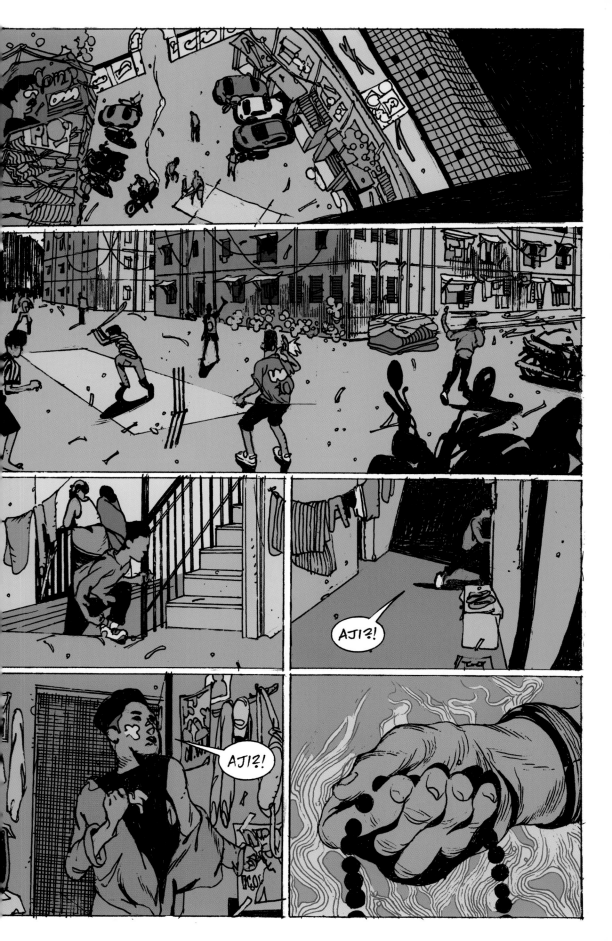

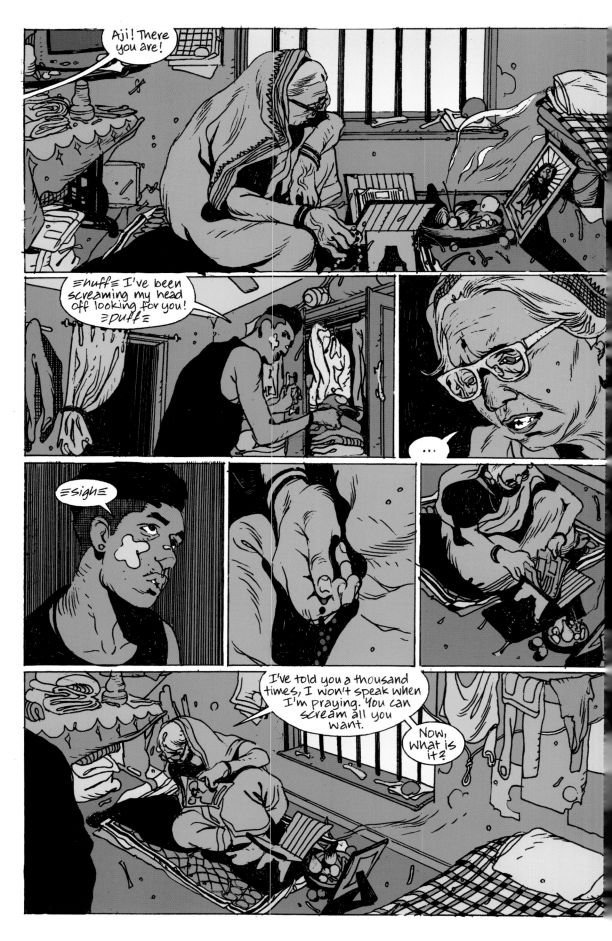

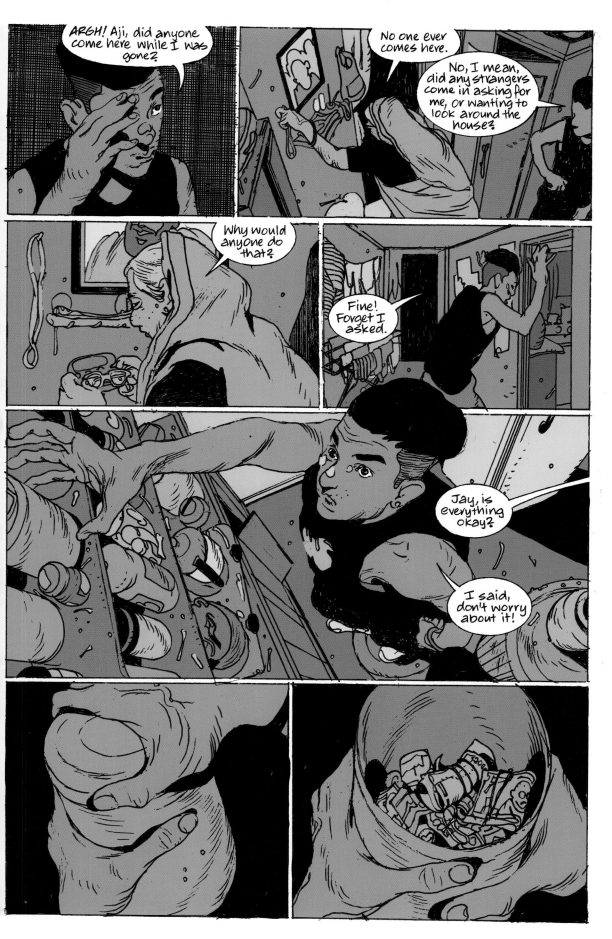

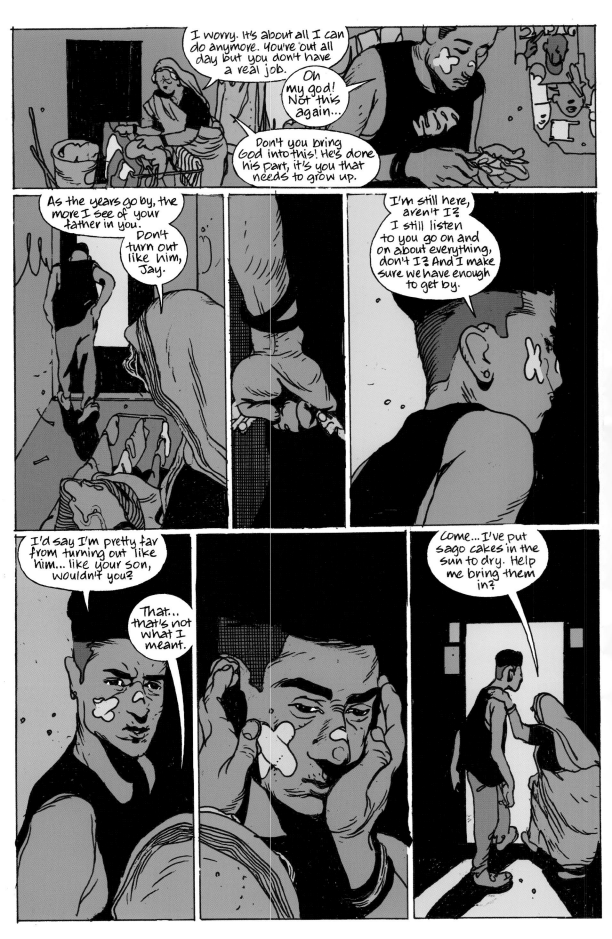

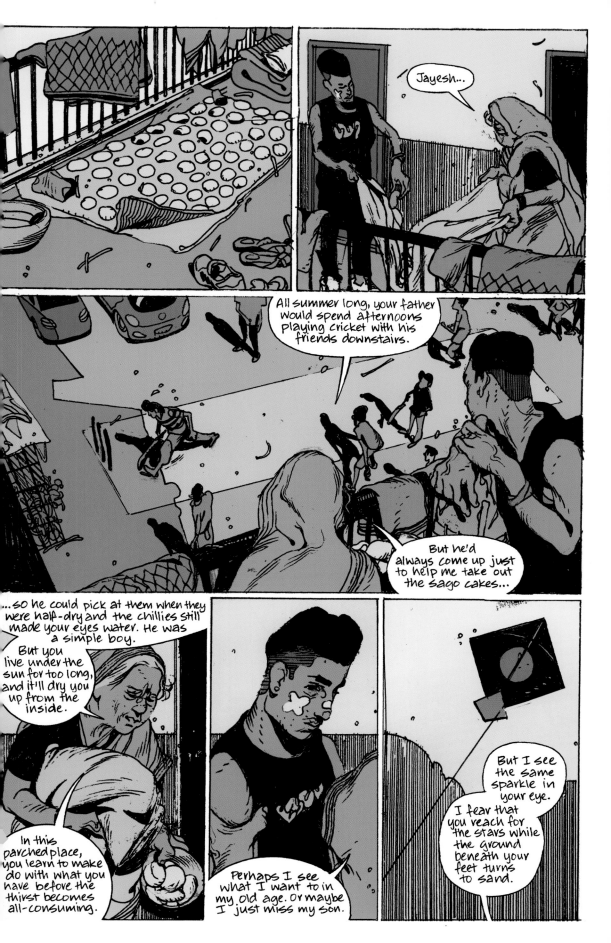

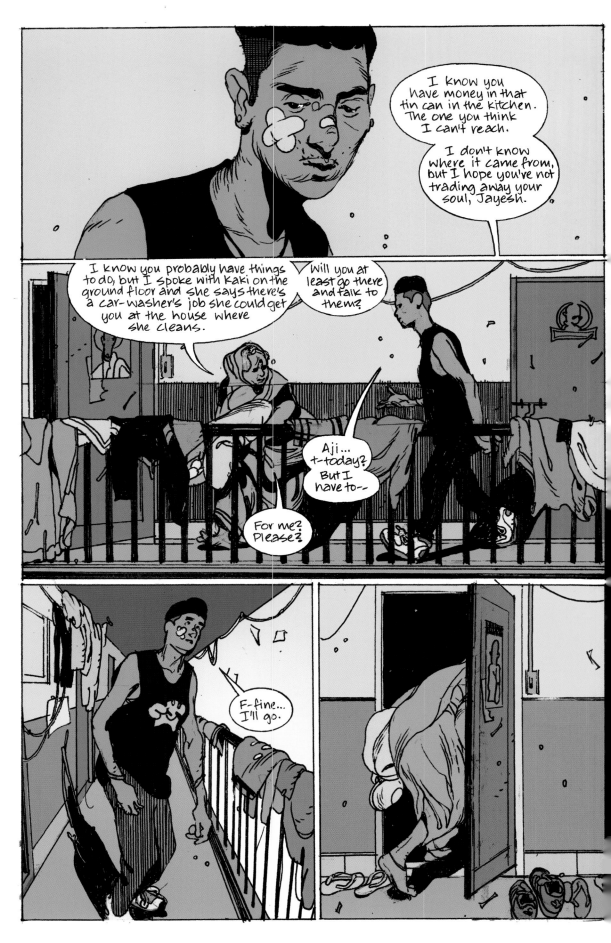

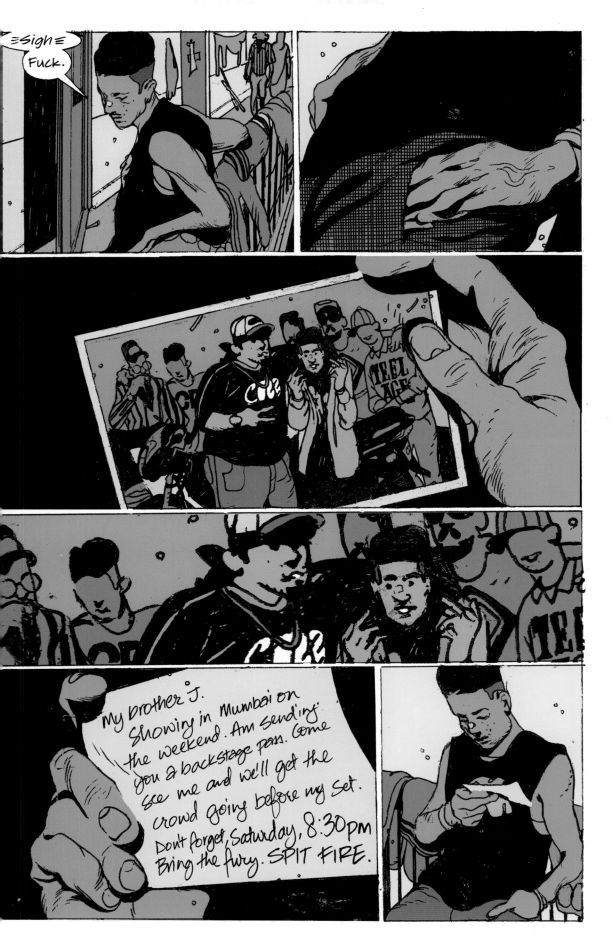

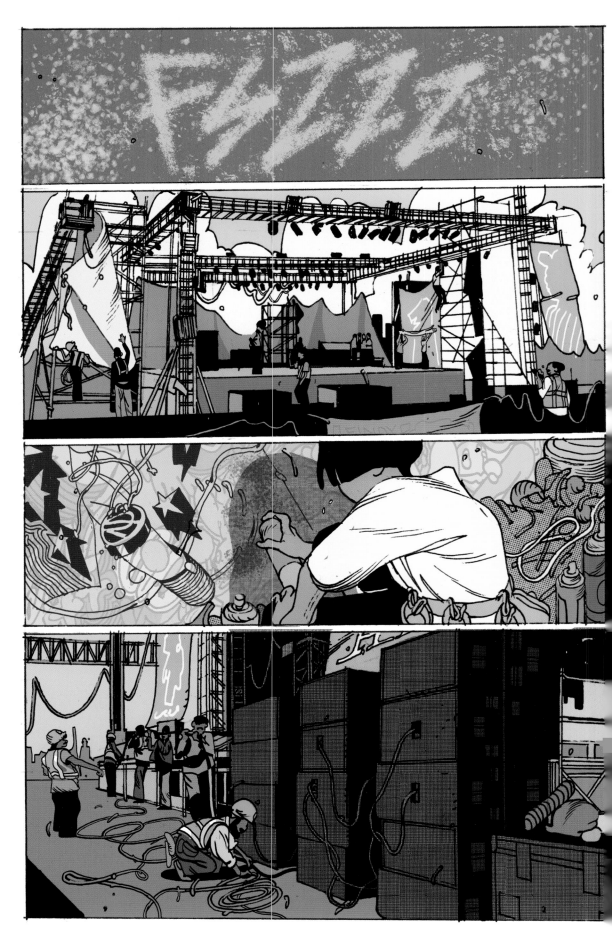

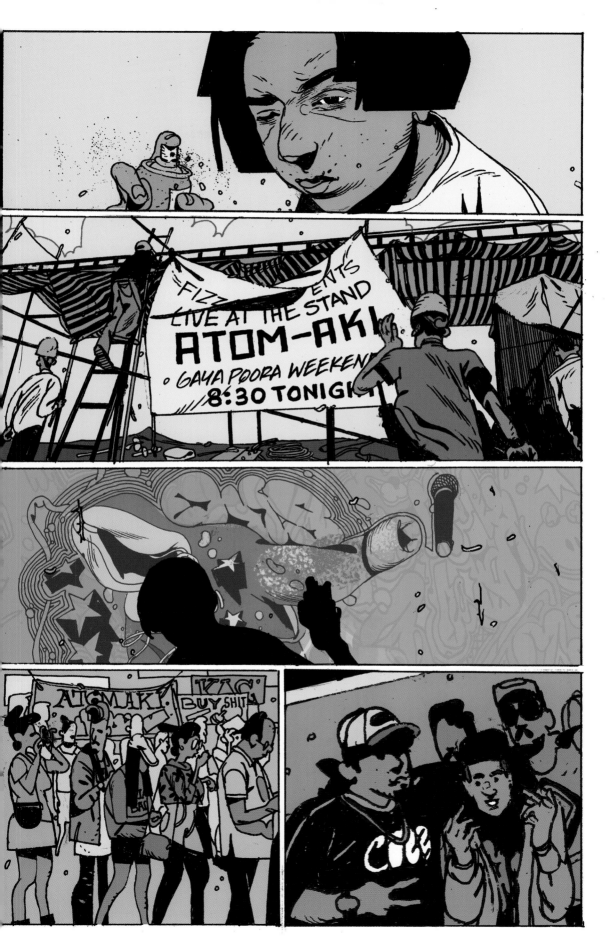

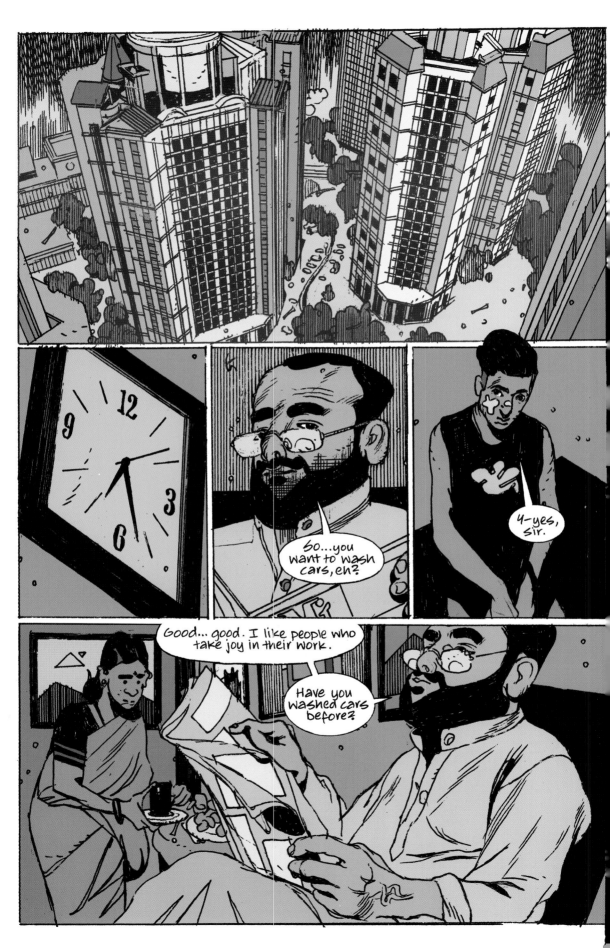

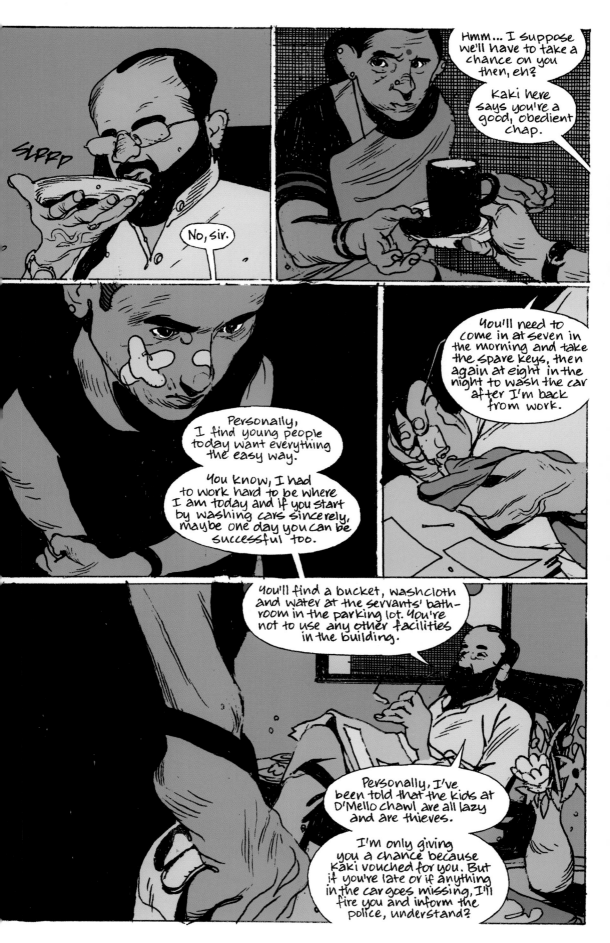

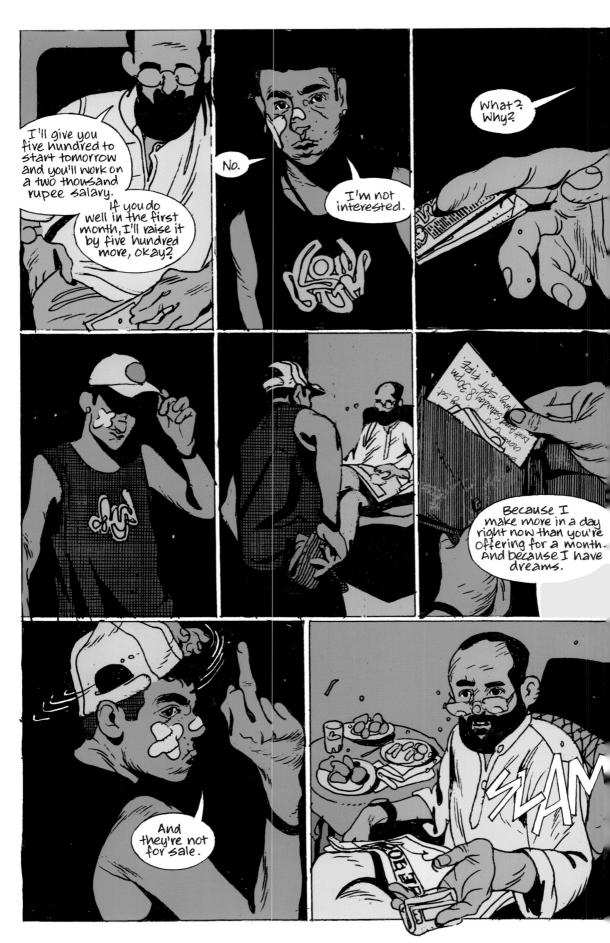

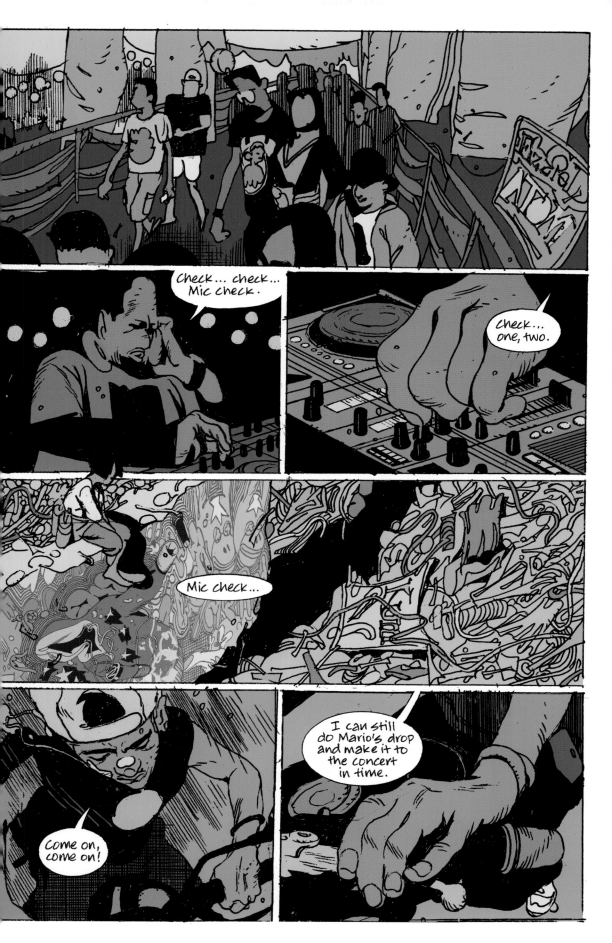

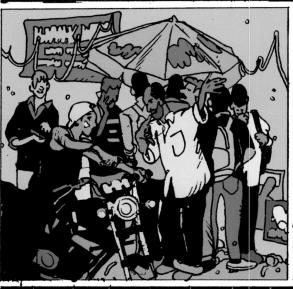

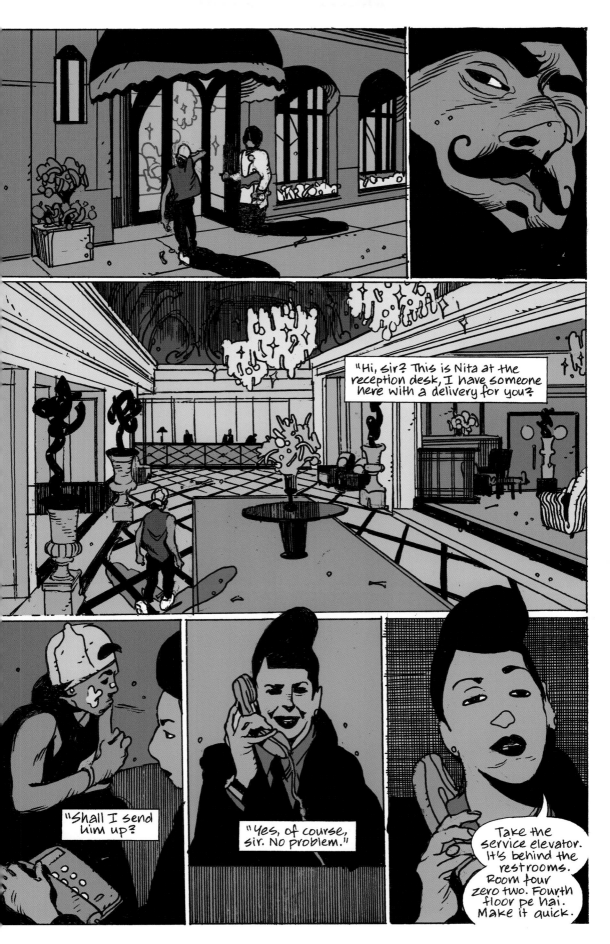

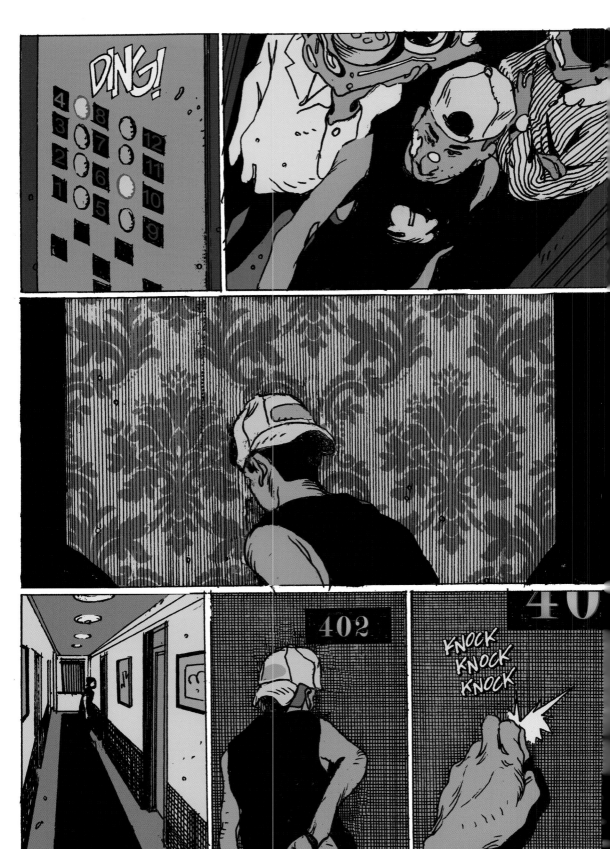

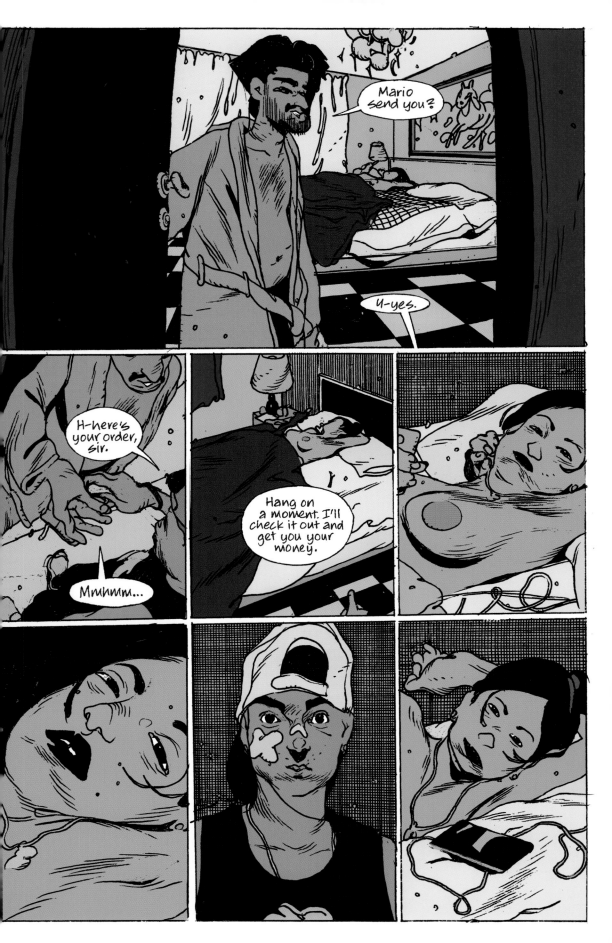

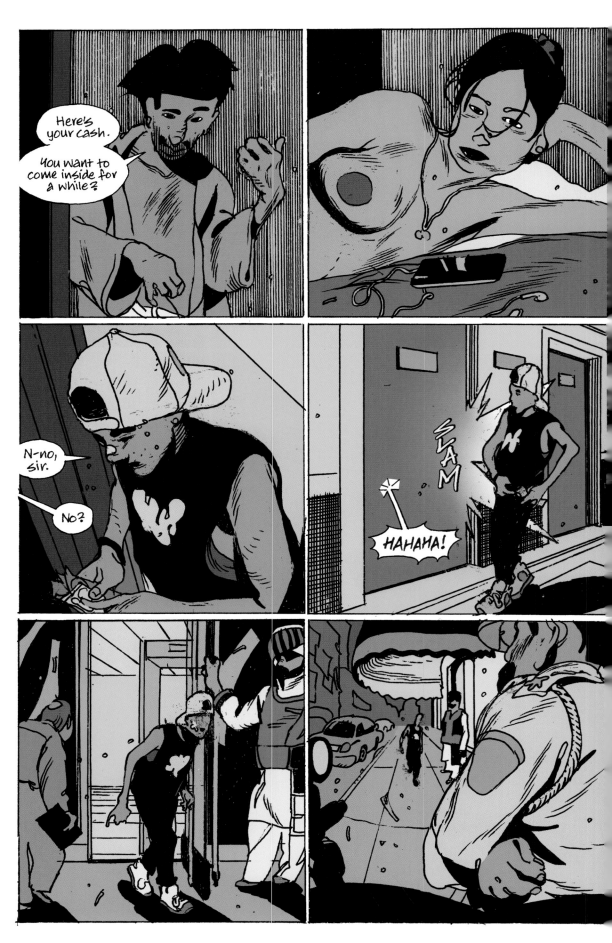

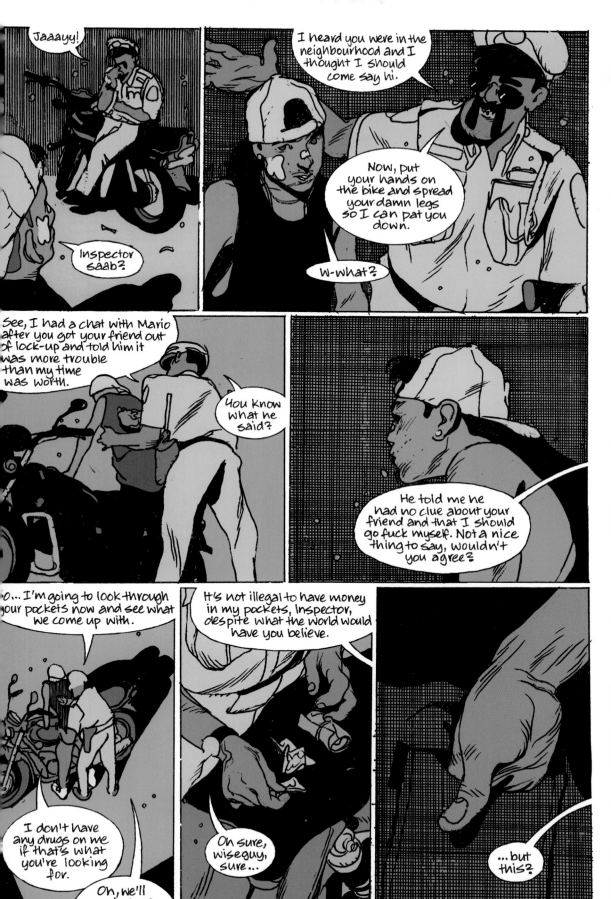

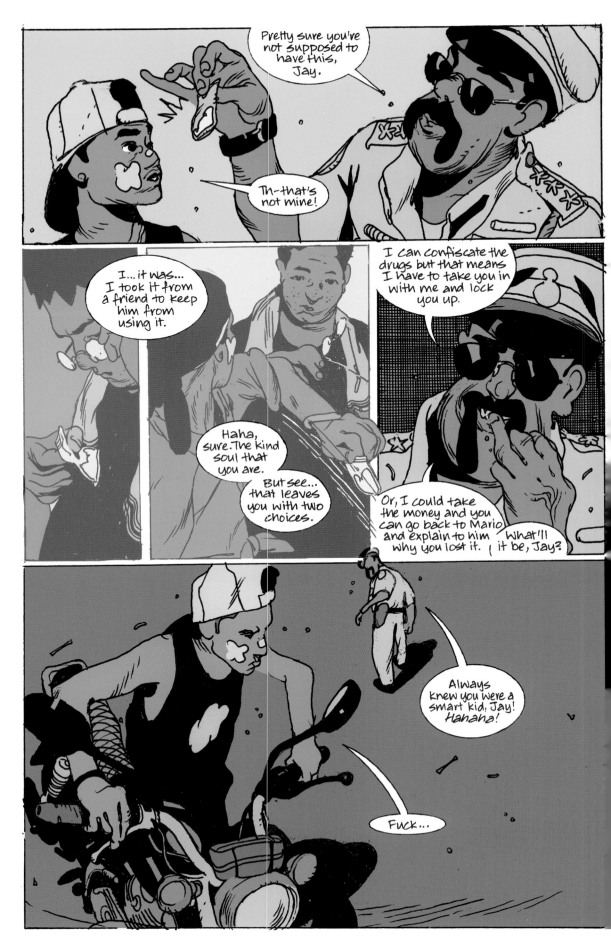

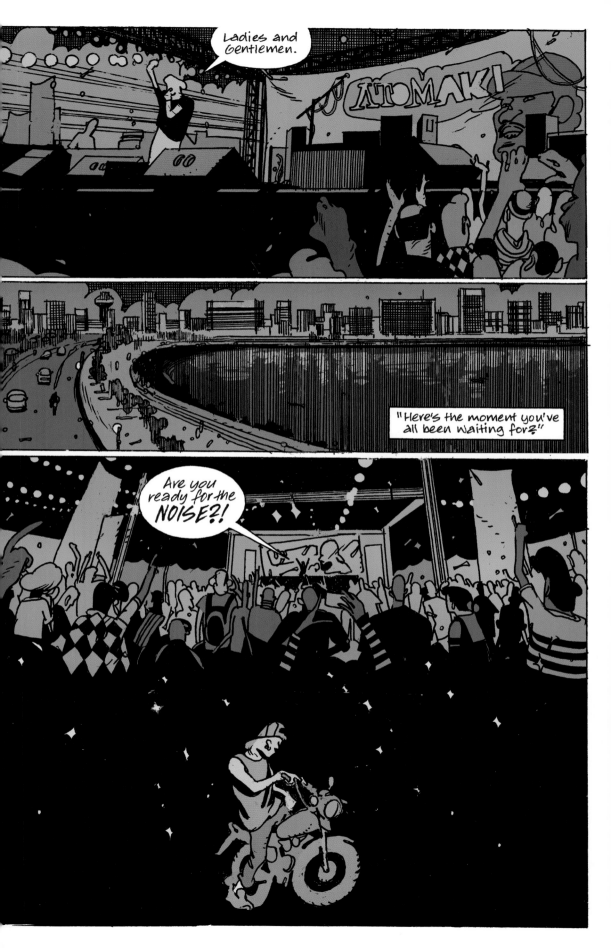

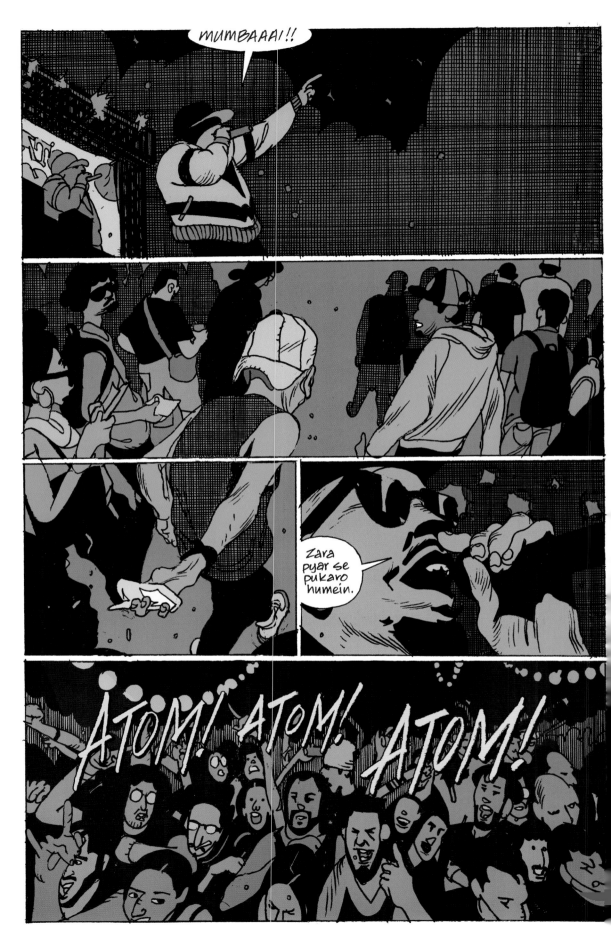

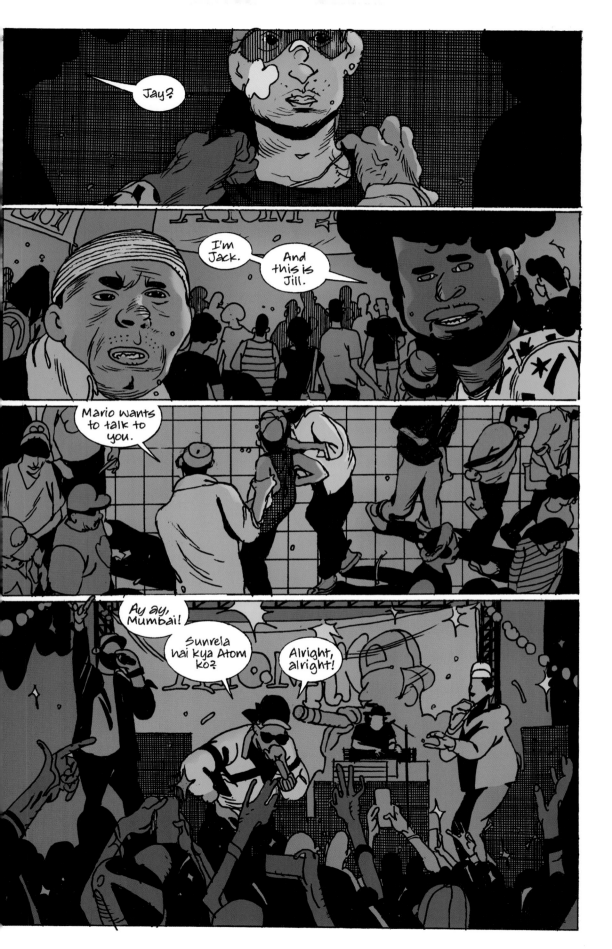

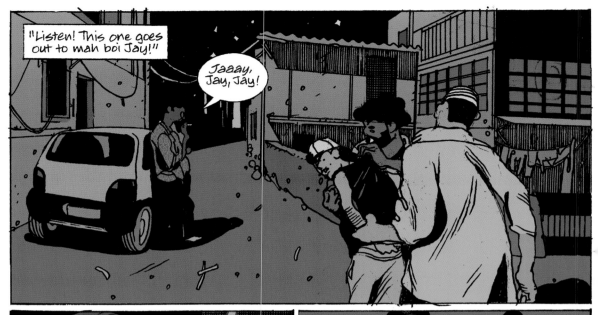

"Listen! This one goes out to mah boi Jay!"

Jaaay, Jay, Jay!

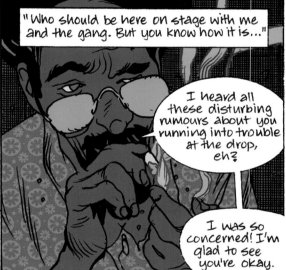

"Who should be here on stage with me and the gang. But you know how it is..."

I heard all these disturbing rumours about you running into trouble at the drop, eh?

I was so concerned! I'm glad to see you're okay.

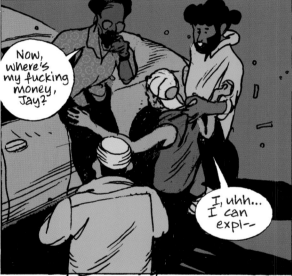

Now, where's my fucking money, Jay?

I, uhh... I can expl--

It's Mumbai, eh? Everyone's always running late!

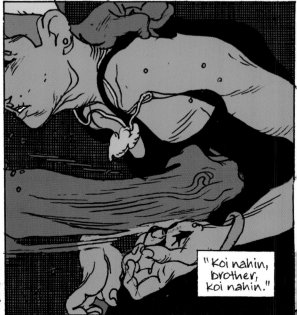

"Koi nahin, brother, koi nahin."

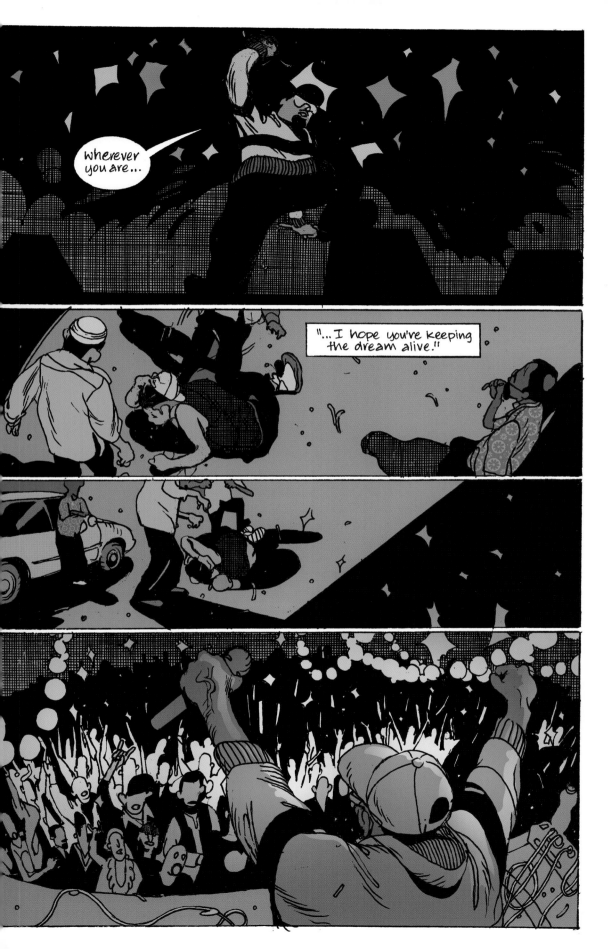

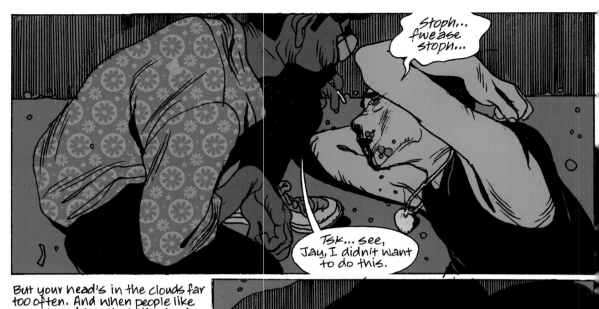

Stoph... fwease stoph...

Tsk... See, Jay, I didn't want to do this.

But your head's in the clouds far too often. And when people like you start doing that, it's bad for business.

So enough. Enough with the attitude and the medallions and the stupid fucking caps and the hoodies.

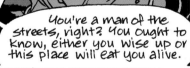

You're a man of the streets, right? You ought to know, either you wise up or this place will eat you alive.

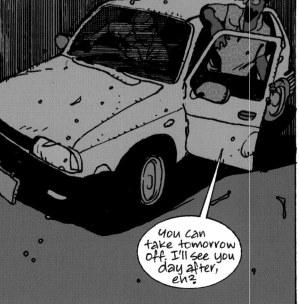

You can take tomorrow off. I'll see you day after, eh?

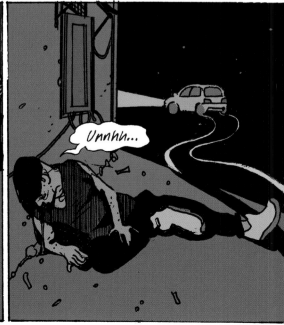

Unnhh...

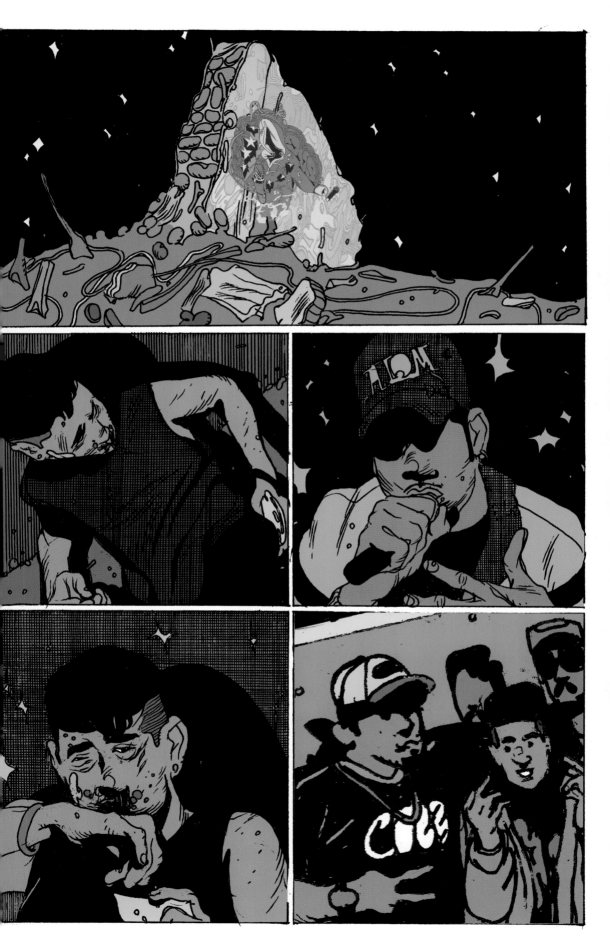

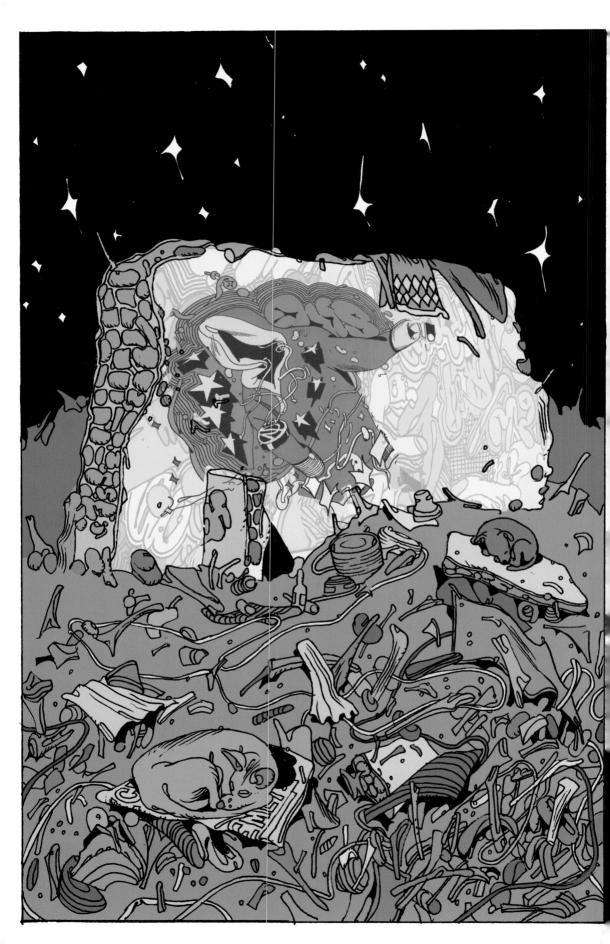

CHAPTER 3

DRAGON WOK

INDIAN STYLE CHINESE

SOUP VEG

Veg Soup	60.00
Veg Sweet Corn	60.00
Plain Sweet Corn	60.00
Veg Hot & Sour	60.00
Veg Manchow	60.00
Veg Talumein	60.00
Veg Noodles Soup	60.00
Veg Clear	50.00
Tomato Soup	70.00
Veg Sezwan Soup	70.00

VEG FRIED RICE

Veg Special Rice
Veg Chopar Rice
Veg Singapore Fried Rice
Veg Hong Kong Fried Rice
Veg Tripple Rice
Veg Tripple Sezwan Rice
Veg Combination Rice
Veg Sezwan Combination Rice
Veg Steward Rice
Veg Shanghai Rice
Veg Fried Rice

VEG FRIED RICE WI...

0.00	Fried Rice with Veg Chill
0.00	Fried Rice with Veg Hon
0.00	Fried Rice with Hot Garli
0.00	Fried Rice with Sezwan
0.00	Fried Rice with Ginger
0.00	Fried Rice with Manchur
0.00	Singapore rice with Veg
0.00	Shanghai with Veg Ball
0.00	
0.00	
0.00	

Ready hai!

VEG GRAVY OR DRY

Veg Chilly	120.00
Veg Manchurian	120.00
Veg Sweat Garlic Sauce	130.00
Veg Chow Chow	130.00
Veg Sweet & Sour	130.00
Veg Hong Kong	140.00
Veg Ginger	130.00
Veg Hot Garlic Sauce	130.00
Veg Sezwan Sauce	130.00
Veg Crispy Sauce	170.00

VEG FRIED RICE WITH VEG

Fried Rice with Veg Chilly Dry
Fried Rice with Veg Hong Kong
Fried Rice with Hot Garlic Sauce
Fried Rice with Sezwan Ball
Fried Rice with Ginger

'Pecial fried rice!

PANEER GRAVY O...

Paneer 65
Paneer Chilly
Paneer Machurian
Paneer Sweet Garlic Sauce
Paneer Sweet & Sour
Paneer Ginger
Paneer Hot Garlic Chow
Paneer Hong Kong
Paneer Sezwan

VEG NOODLES

eg Singapore Noodles	11
eg Hong Kong Noodles	11
eg Tripple Sezwan Noodles	14
eg Sezwan Noodles	10
eg Sezwan Noodles (Half)	6
eg. Hakka Noodles	9
eg. Hakka Noodles (Half)	5
eg Chow Mein	9
eg Chinese Chopsuey	10
eg American Chopsuey	9
eg Chinese Bhel	9

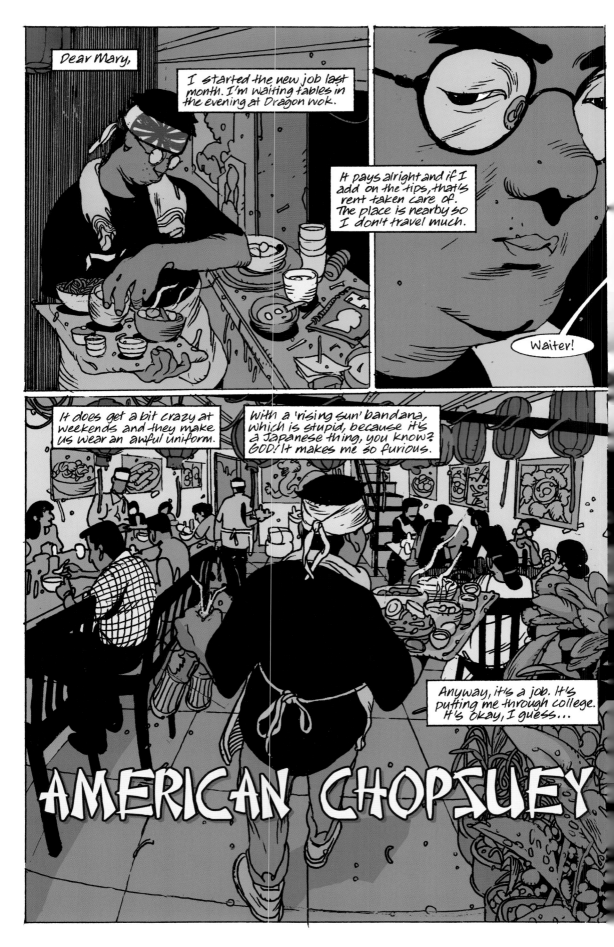

AMERICAN CHOPSUEY

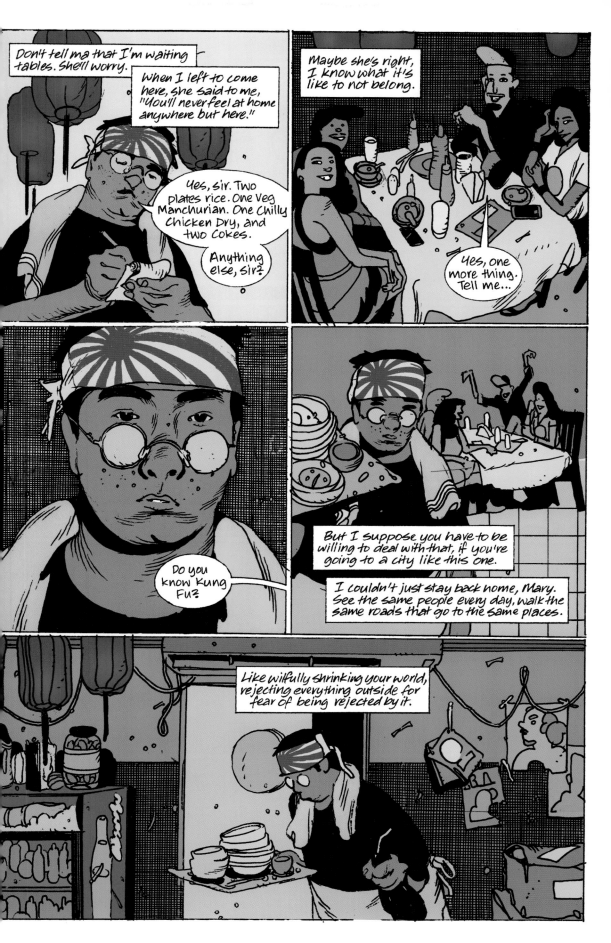

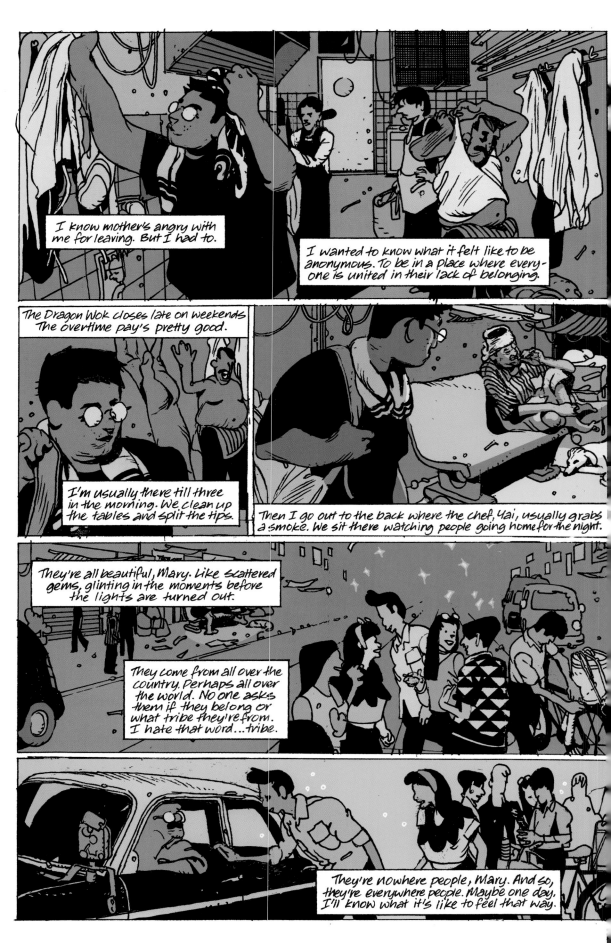

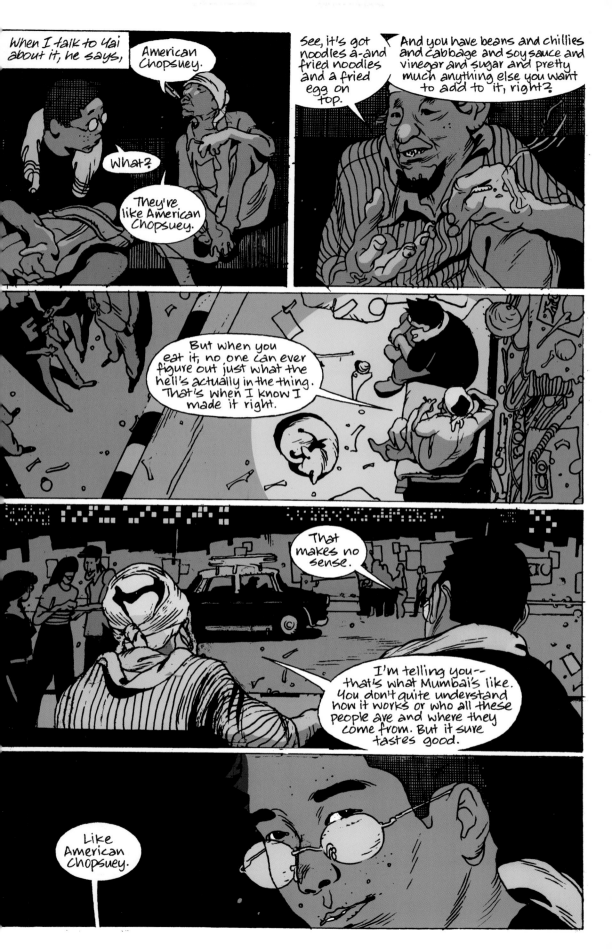

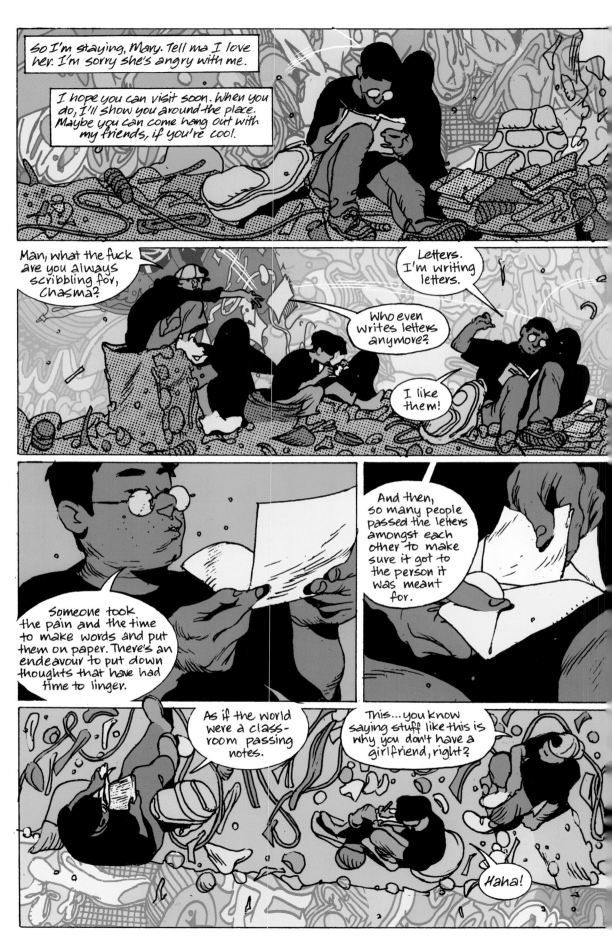

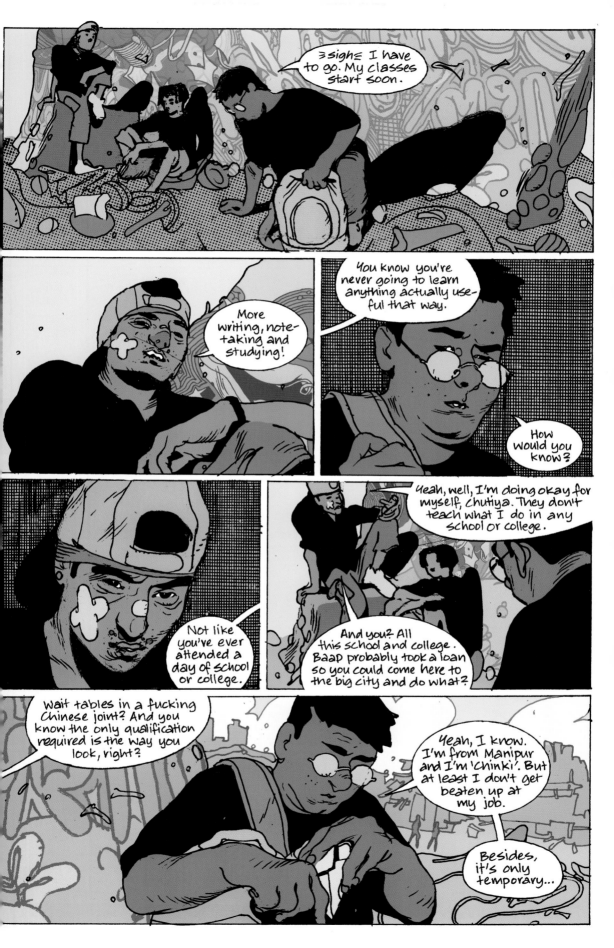

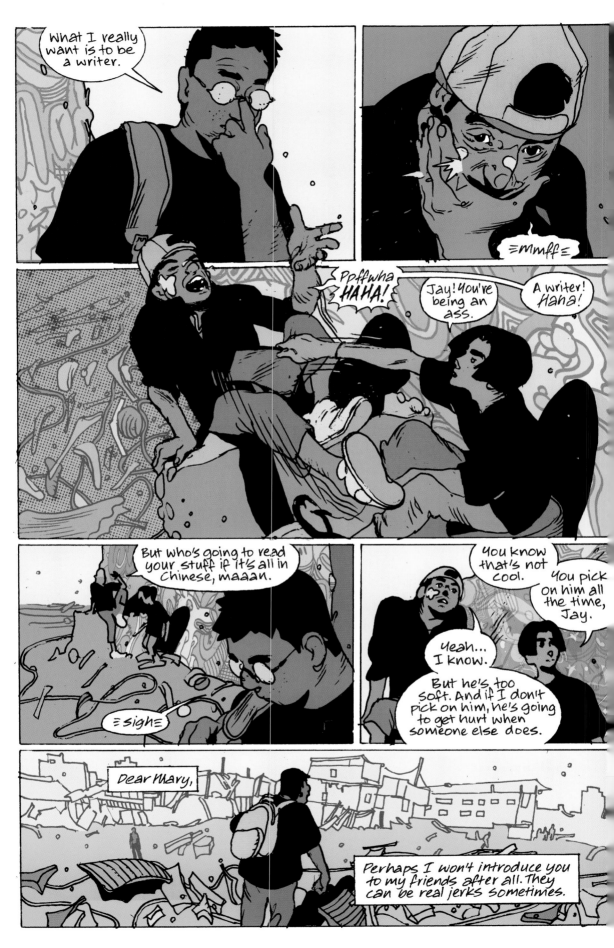

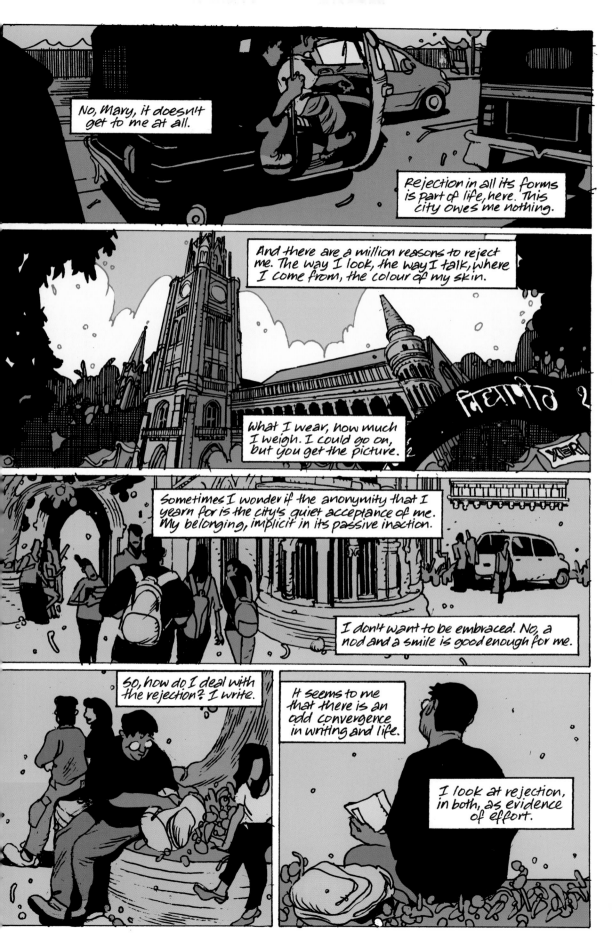

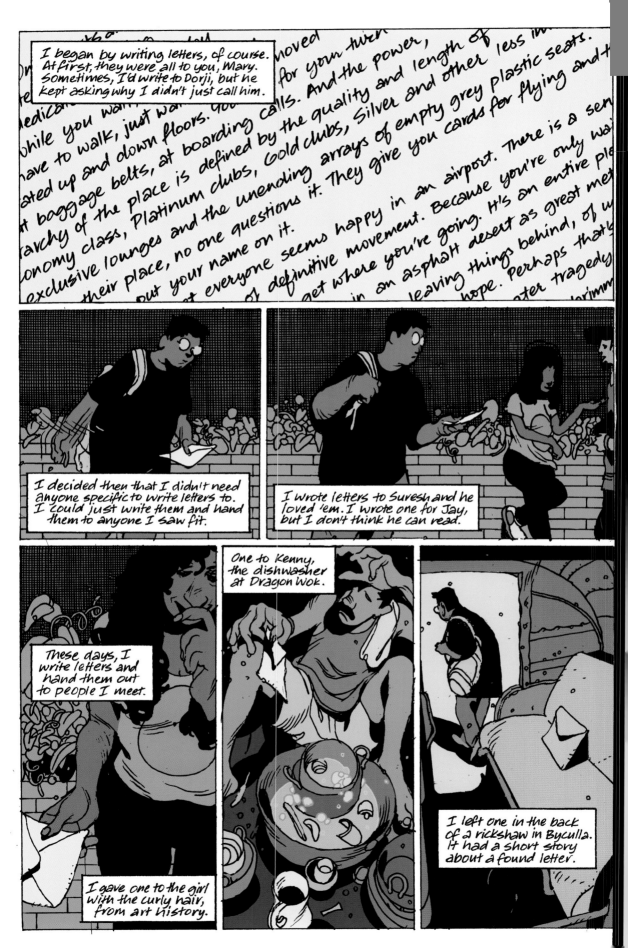

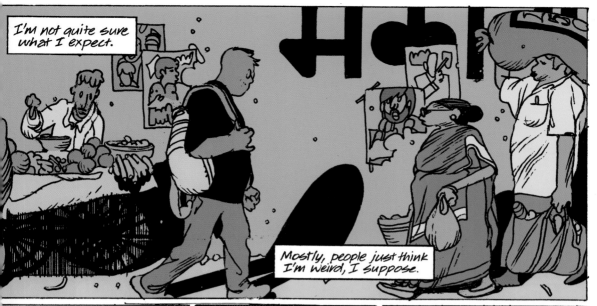

I'm not quite sure what I expect.

Mostly, people just think I'm weird, I suppose.

I get ignored a lot. I know that a great number of the letters that I write won't even be opened.

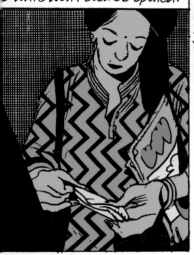

There was a girl once who took my letter, frowned, walked over to a trash bin and dropped it in. She never broke eye contact the whole time.

She hated me, Mary. I could feel it in her eyes. I don't understand that kind of animosity.

I get laughed at, of course. Mostly it's just harmless amusement.

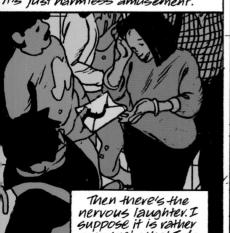

Then there's the nervous laughter. I suppose it is rather unusual, what I do.

And then there's ridicule...which I think I hate the most. I gave a letter to a friend in the canteen once.

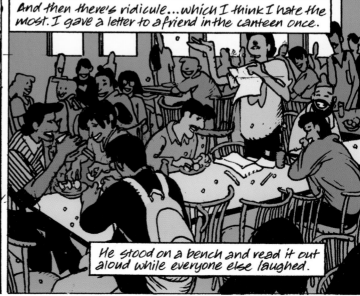

He stood on a bench and read it out aloud while everyone else laughed.

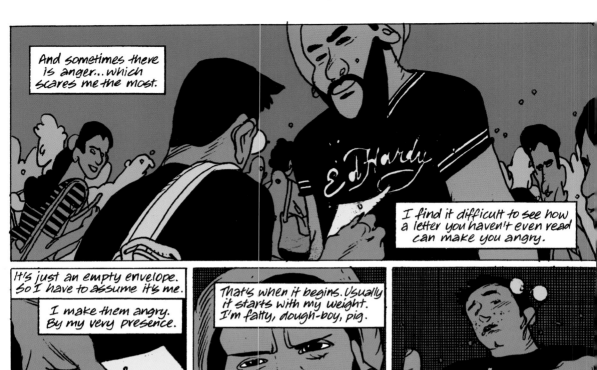

And sometimes there is anger...which scares me the most.

I find it difficult to see how a letter you haven't even read can make you angry.

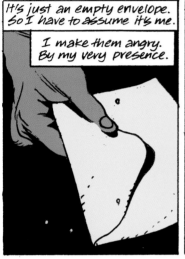

It's just an empty envelope. So I have to assume it's me.

I make them angry. By my very presence.

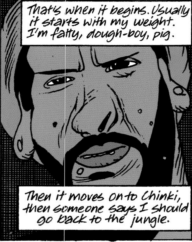

That's when it begins. Usually it starts with my weight. I'm fatty, dough-boy, pig.

Then it moves on to Chinki, then someone says I should go back to the jungle.

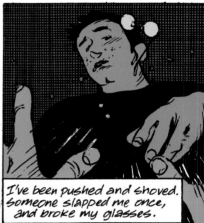

I've been pushed and shoved. Someone slapped me once, and broke my glasses.

I am not brave enough to fight back. I abhor violence.

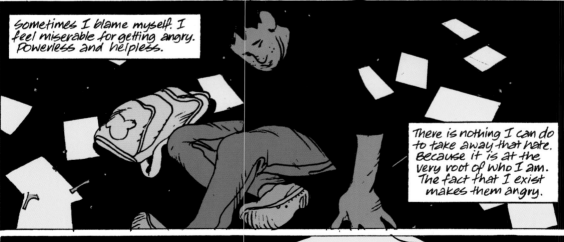

Sometimes I blame myself. I feel miserable for getting angry. Powerless and helpless.

There is nothing I can do to take away that hate. Because it is at the very root of who I am. The fact that I exist makes them angry.

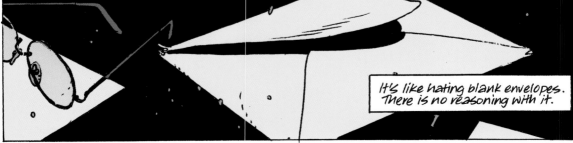

It's like hating blank envelopes. There is no reasoning with it.

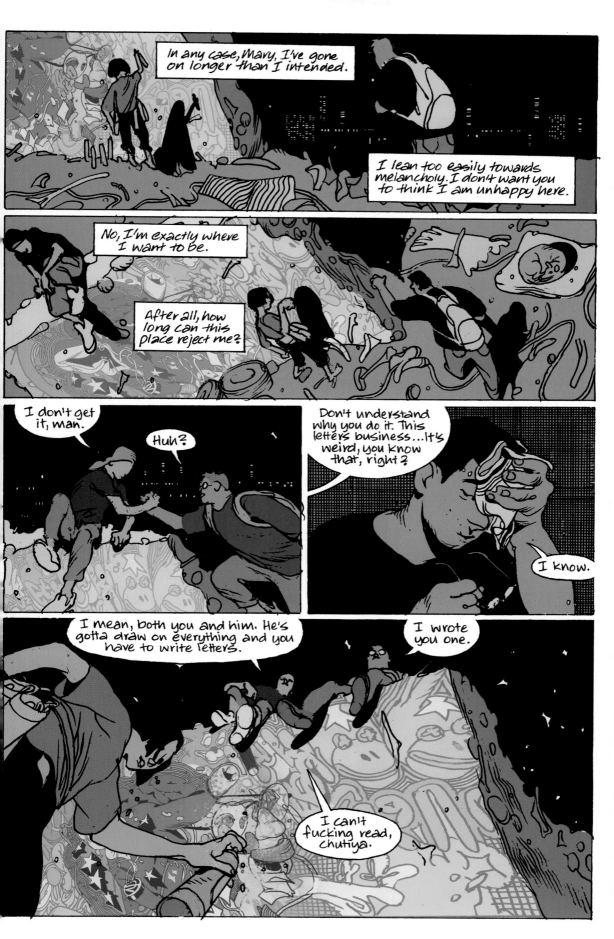

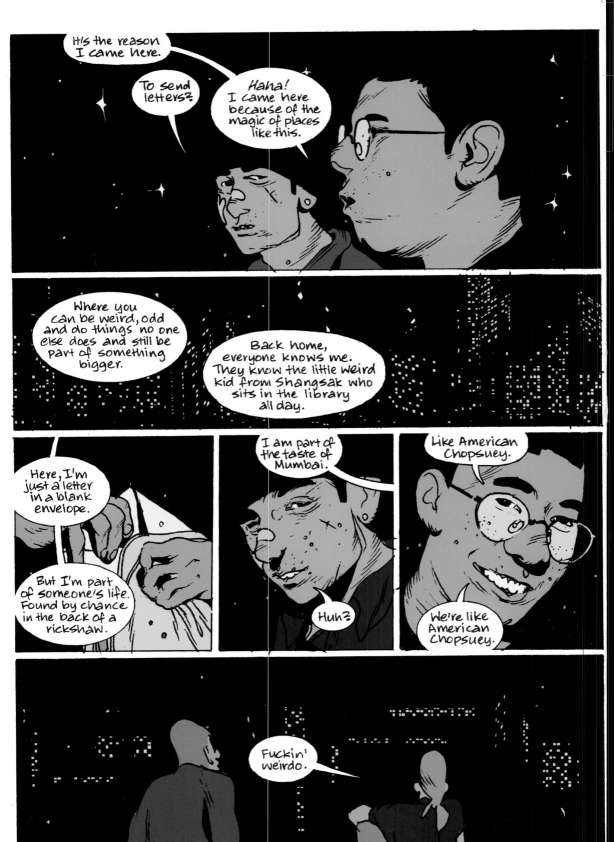

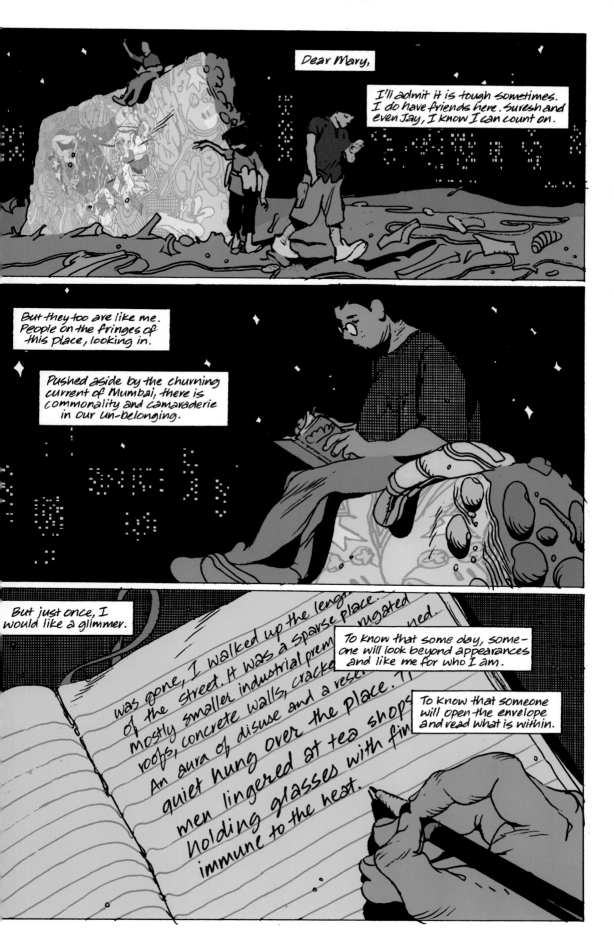

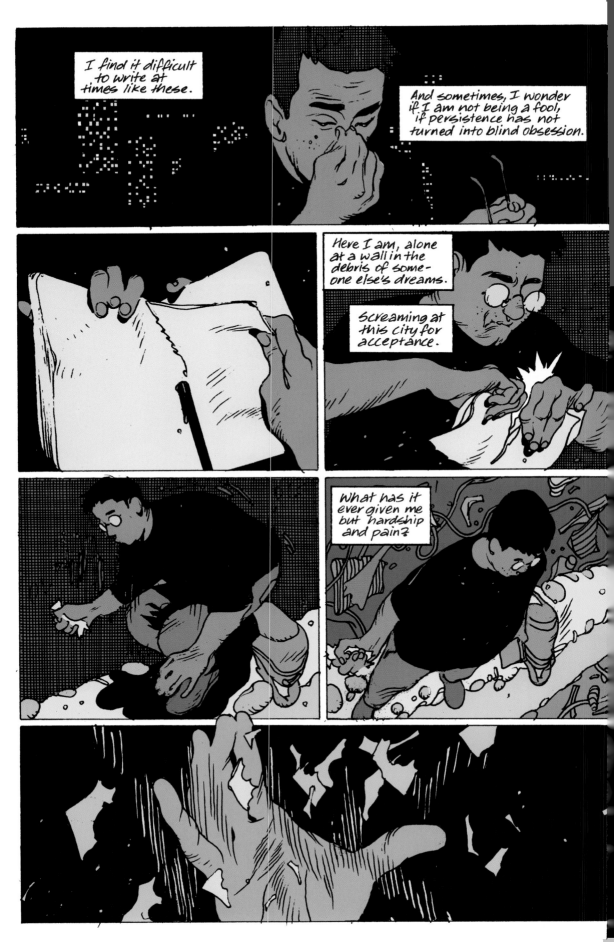

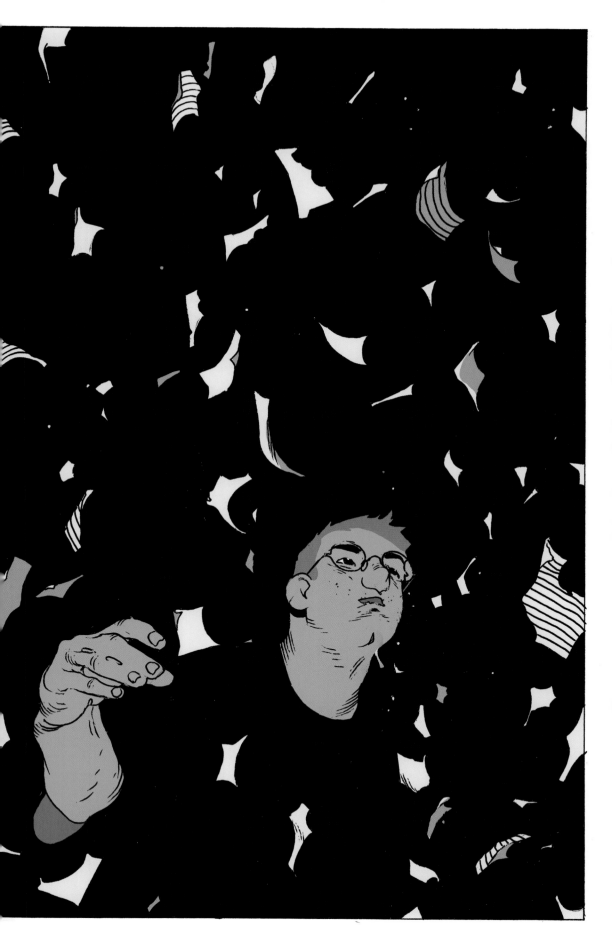

"You wrote this?"

"...made from life and also unmade into it. All the things we gather from eren, the experience of a life and memories, scavenged and picked clean."

"Yes?"

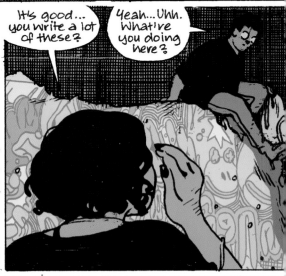

"It's good... you write a lot of these?"

"Yeah...Uhh. What've you doing here?"

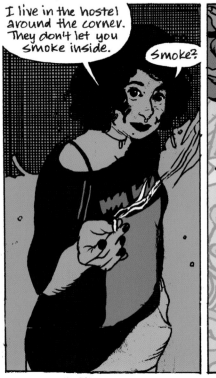

"I live in the hostel around the corner. They don't let you smoke inside."

"Smoke?"

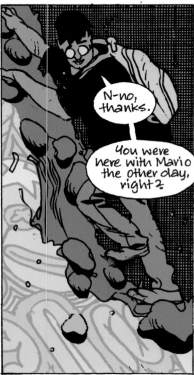

"N-no, thanks."

"You were here with Mario the other day, right?"

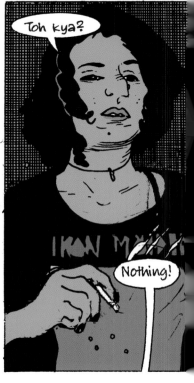

"Toh kya?"

"Nothing!"

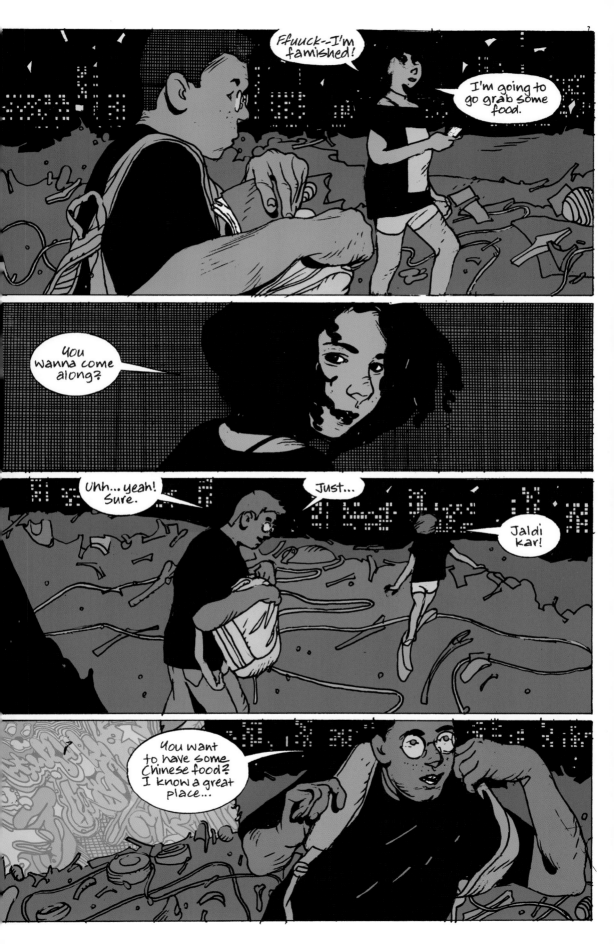

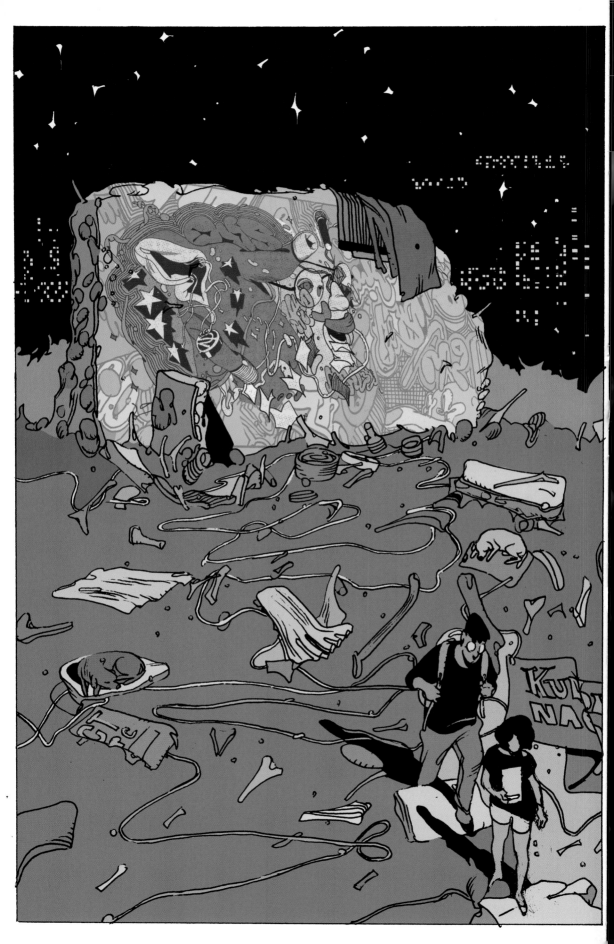

CHAPTER 4

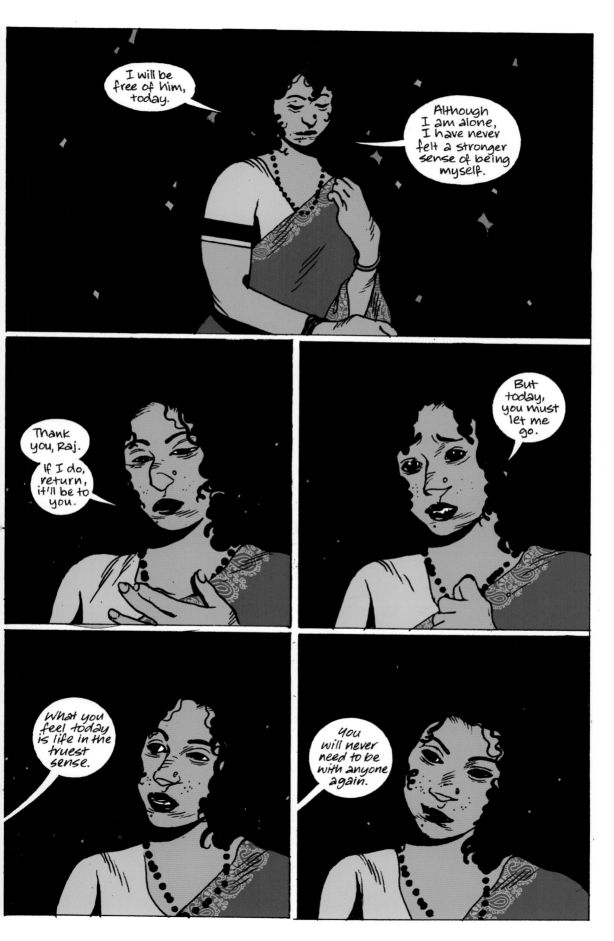

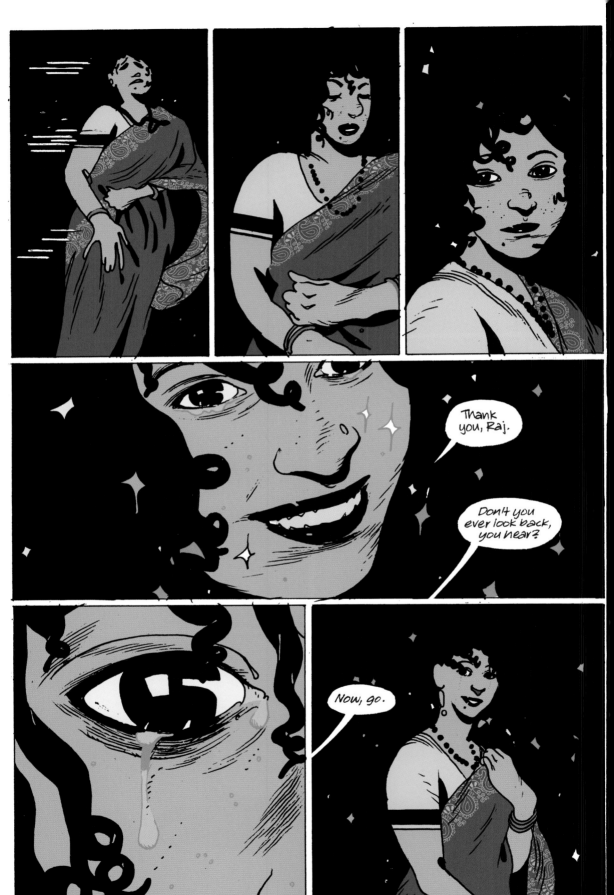

CLAP CLAP CLAP CLAP

BAMBAI TALKIES

Pretty good!

...Amazing!

CLAP CLAP CLAP

Really? You really think so?

Yes! You were beautiful. I mean...

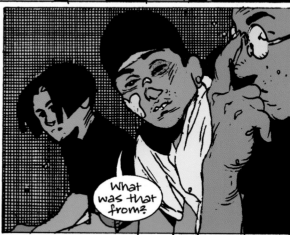

What was that from?

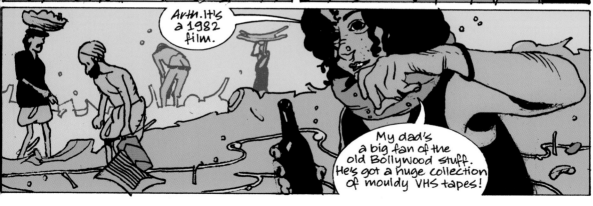

Arth. It's a 1982 film.

My dad's a big fan of the old Bollywood stuff. He's got a huge collection of mouldy VHS tapes!

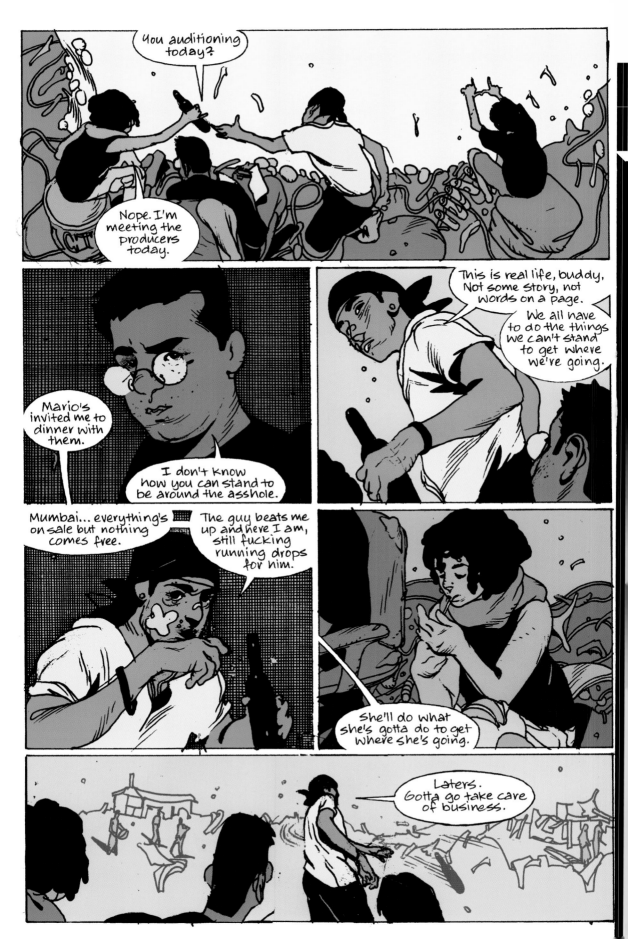

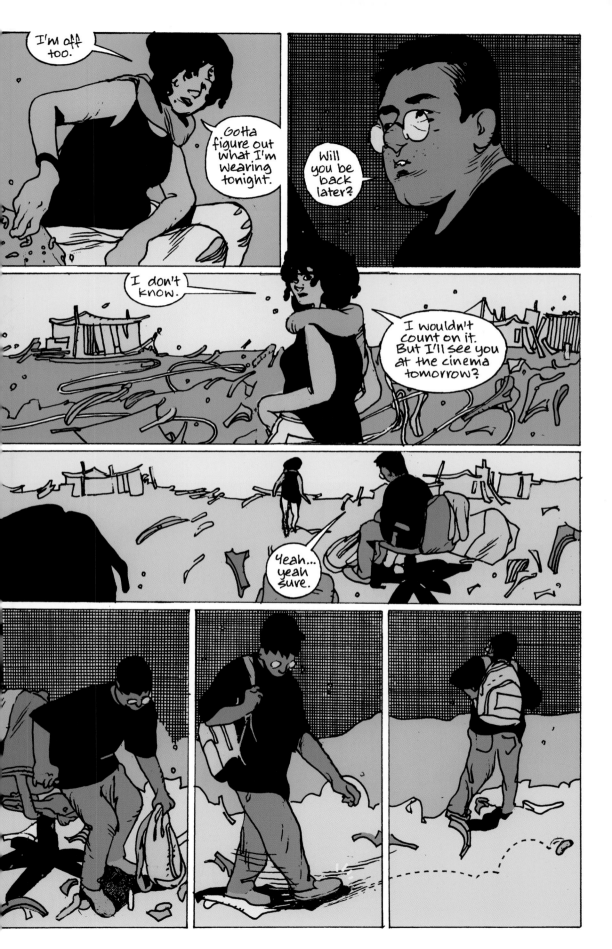

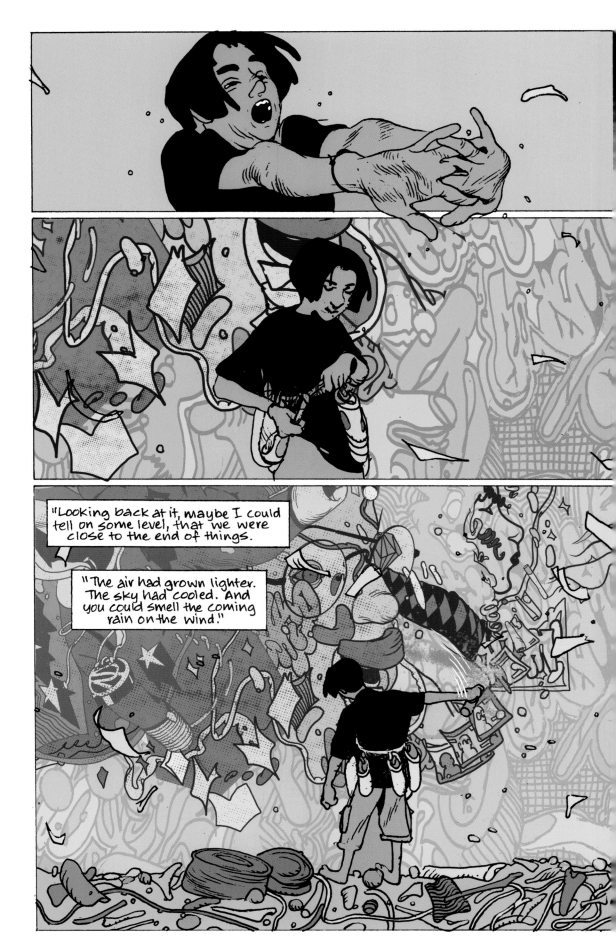

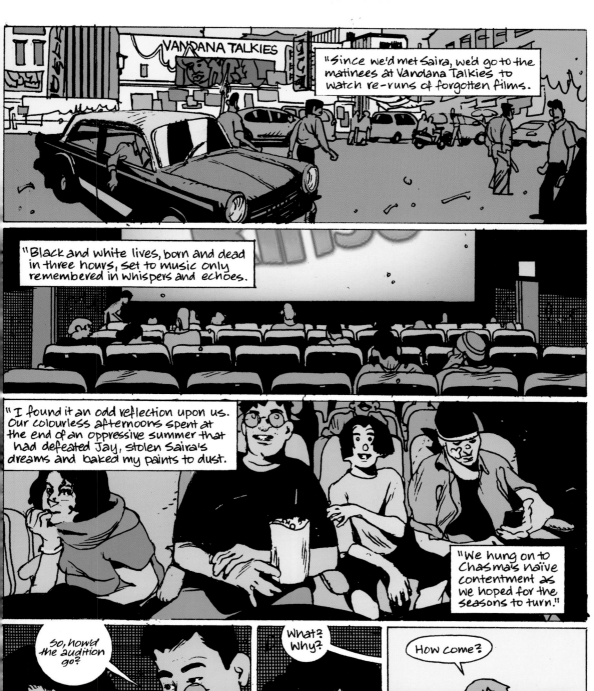

VANDANA TALKIES

"Since we'd met Saira, we'd go to the matinees at Vandana Talkies to watch re-runs of forgotten films.

"Black and white lives, born and dead in three hours, set to music only remembered in whispers and echoes.

"I found it an odd reflection upon us. Our colourless afternoons spent at the end of an oppressive summer that had defeated Jay, stolen Saira's dreams and baked my paints to dust.

"We hung on to Chasma's naïve contentment as we hoped for the seasons to turn."

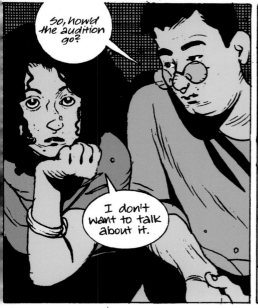

So, how'd the audition go?

I don't want to talk about it.

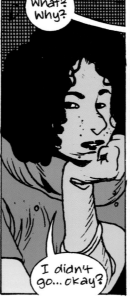

What? Why?

I didn't go... okay?

How come?

SSHH!

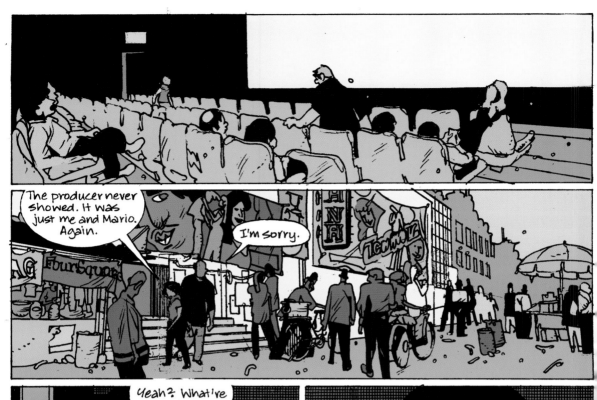

The producer never showed. It was just me and Mario. Again.

I'm sorry.

Yeah? What're you sorry for?

No... I mean. I know you were really looking forward to it.

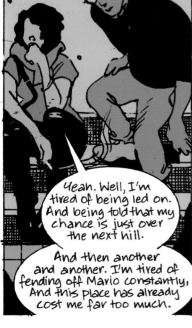

Yeah. Well, I'm tired of being led on. And being told that my chance is just over the next hill.

And then another and another. I'm tired of fending off Mario constantly. And this place has already cost me far too much.

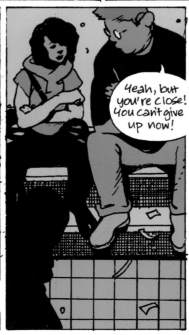

Yeah, but you're close! You can't give up now!

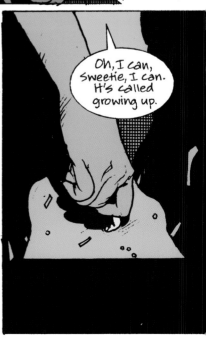

Oh, I can, Sweetie, I can. It's called growing up.

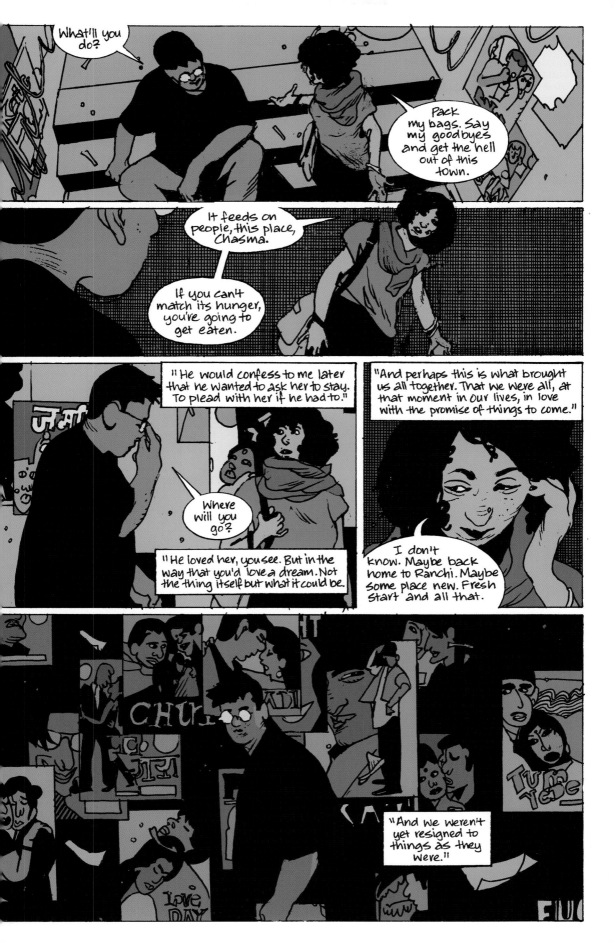

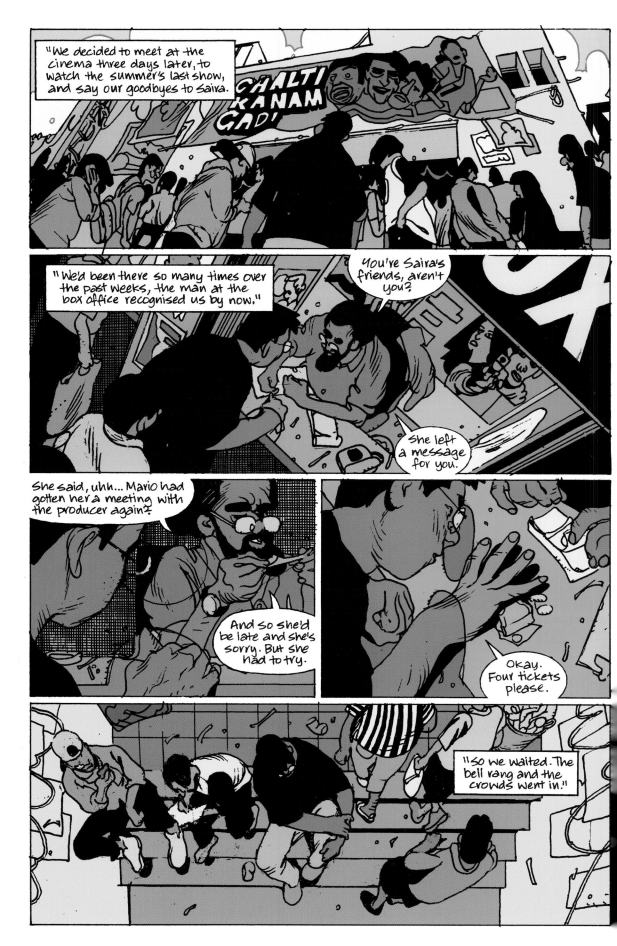

"We decided to meet at the cinema three days later, to watch the summer's last show, and say our goodbyes to Saira.

CHAALTI KA NAM GADI

"We'd been there so many times over the past weeks, the man at the box office recognised us by now."

You're Saira's friends, aren't you?

She left a message for you.

She said, uhh... Mario had gotten her a meeting with the producer again?

And so she'd be late and she's sorry. But she had to try.

Okay. Four tickets please.

"So we waited. The bell rang and the crowds went in."

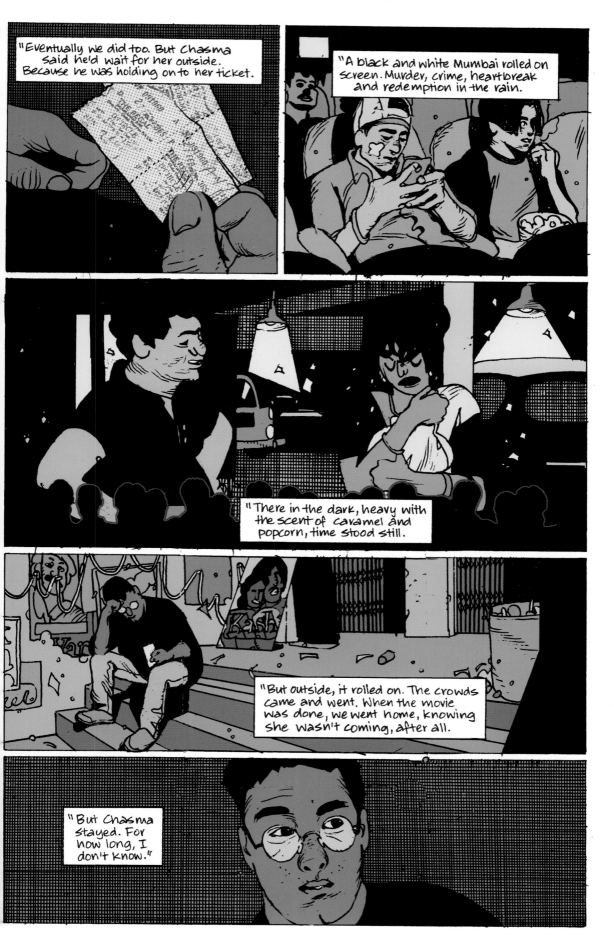

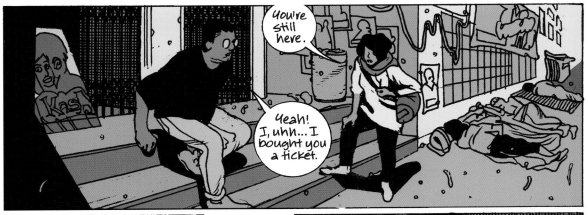

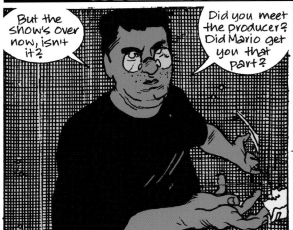

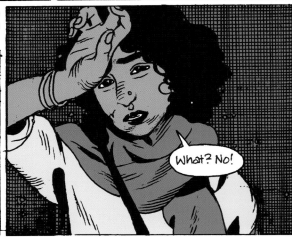

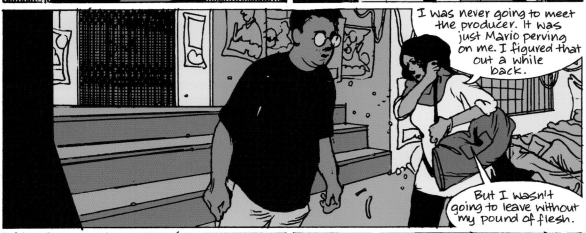

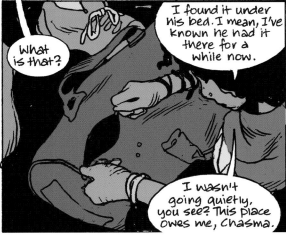

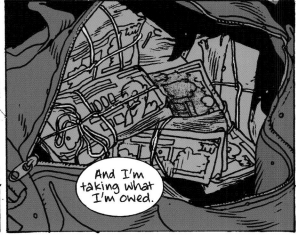

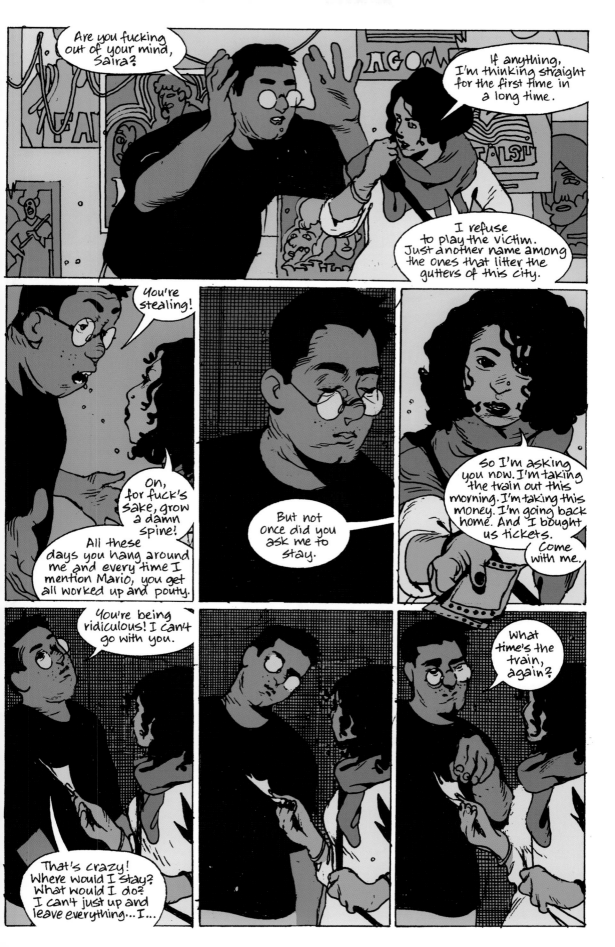

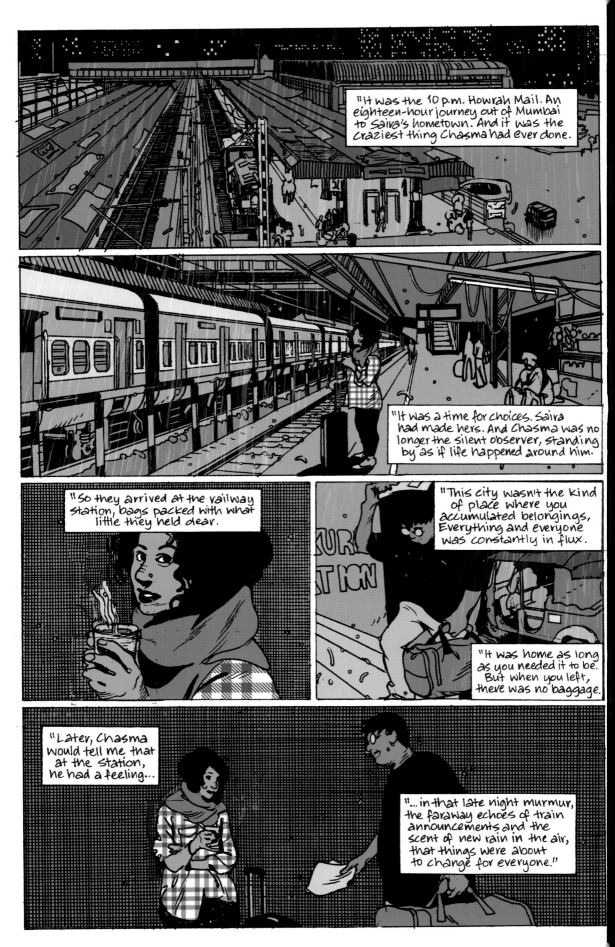

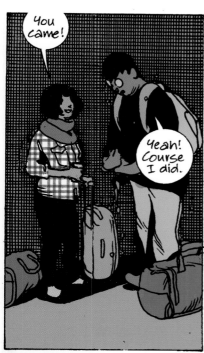

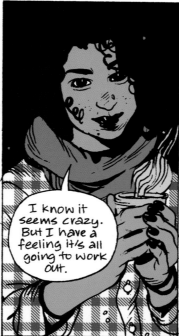

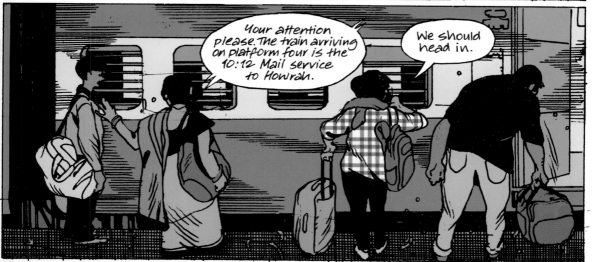

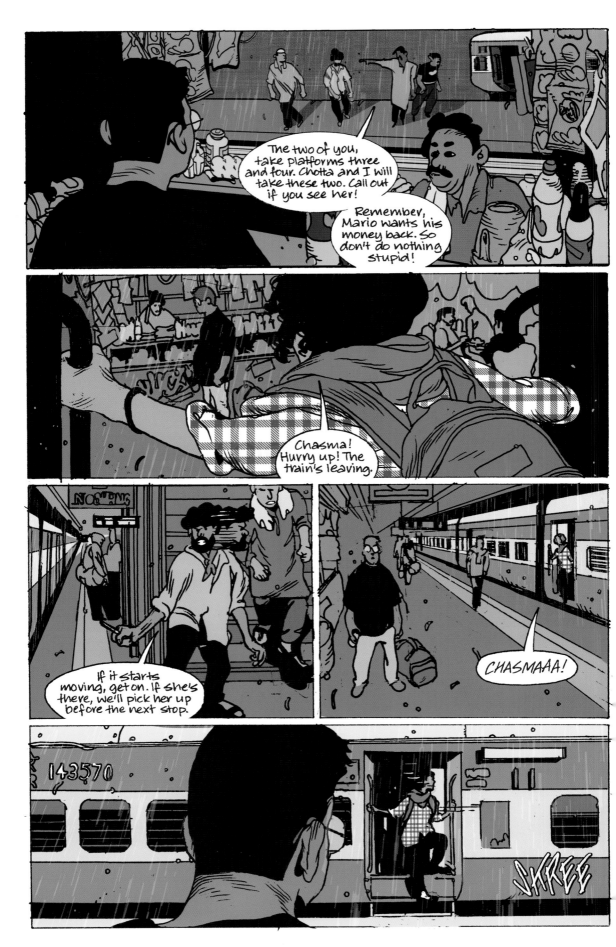

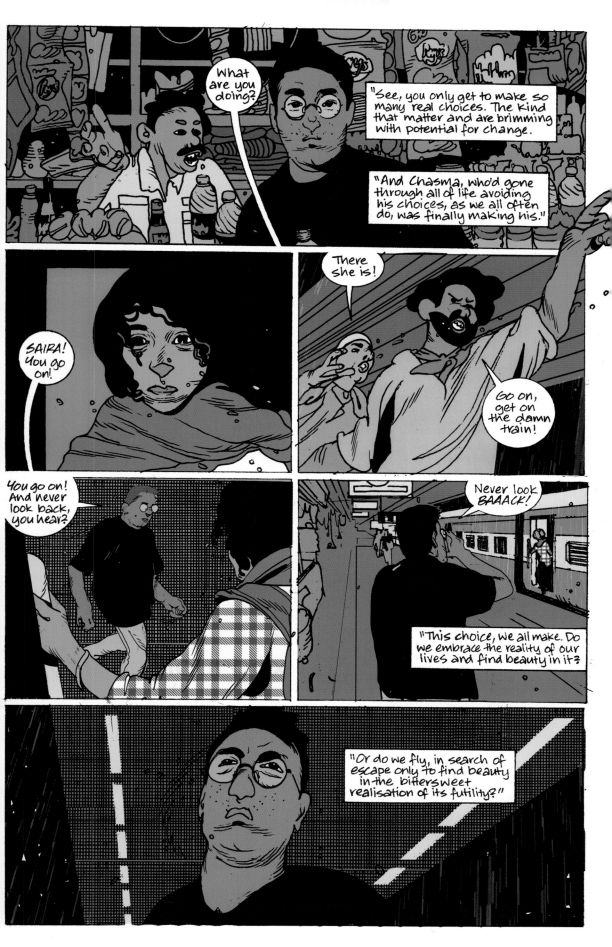

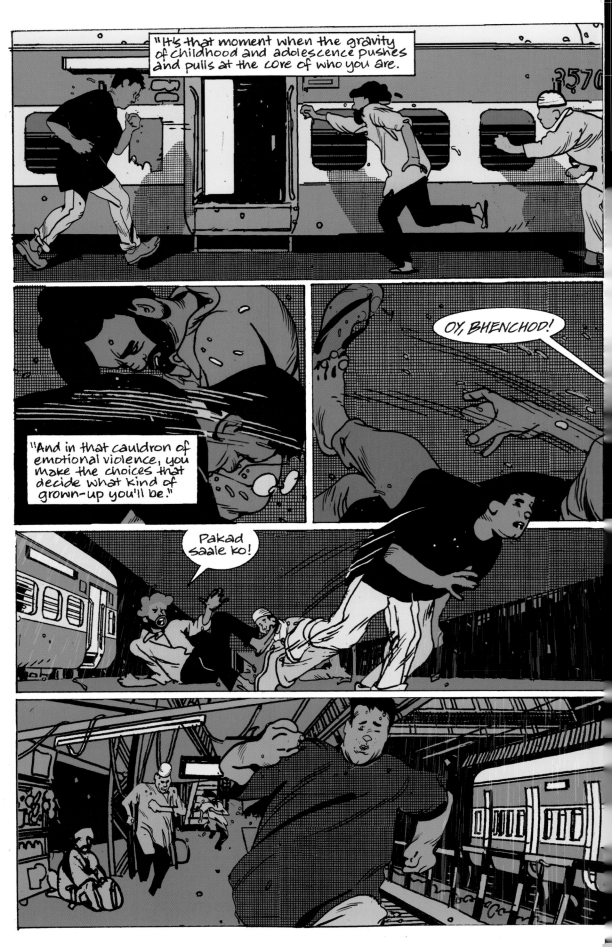

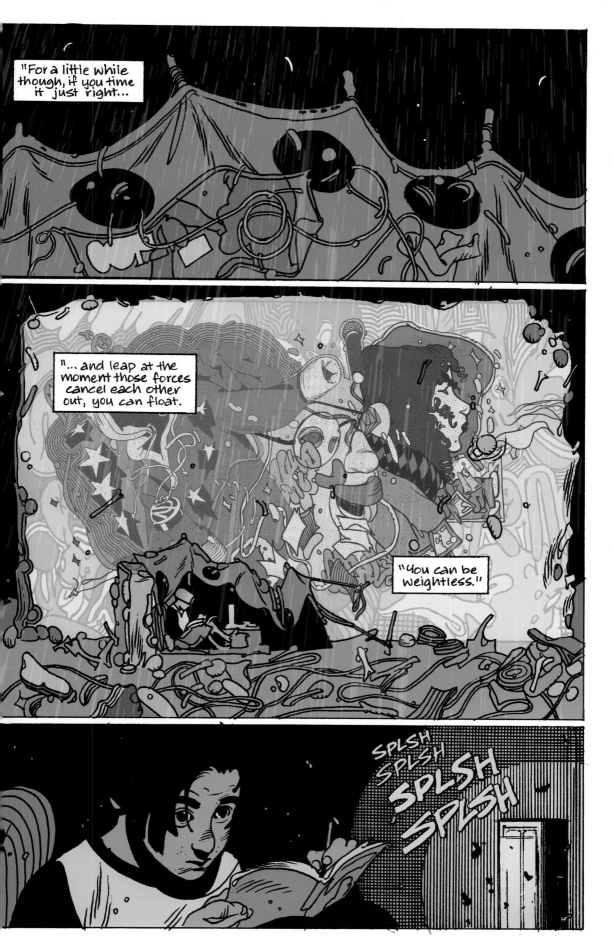

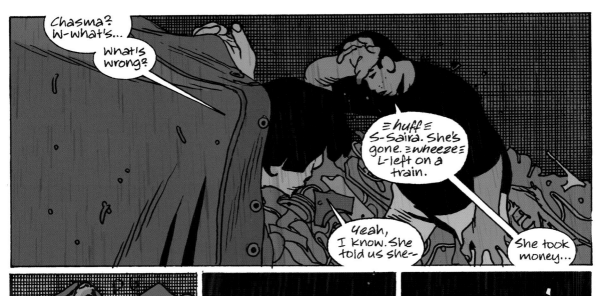

Chasma? W-what's... What's wrong?

≡huff≡ S-Saira. She's gone. ≡wheeze≡ L-left on a train.

Yeah, I know. She told us she—

She took money...

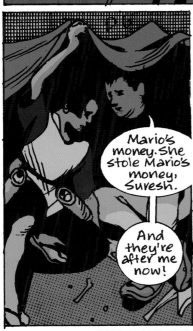

Mario's money. She stole Mario's money, Suresh.

And they're after me now!

So, you know what she did!

I didn't think you'd be stupid enough to come back here after that.

But you keep finding ways to surprise me, don't you, chubby?

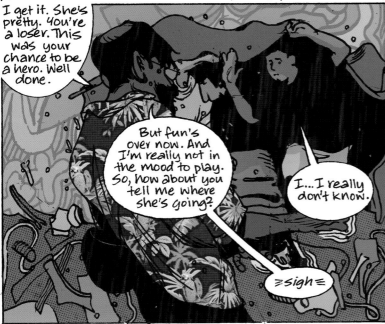

I get it. She's pretty. You're a loser. This was your chance to be a hero. Well done.

But fun's over now. And I'm really not in the mood to play. So, how about you tell me where she's going?

I...I really don't know.

≡sigh≡

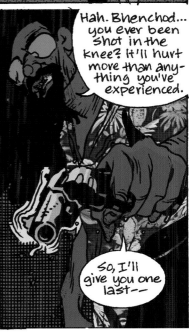

Hah. Bhenchod... you ever been shot in the knee? It'll hurt more than anything you've experienced.

So, I'll give you one last—

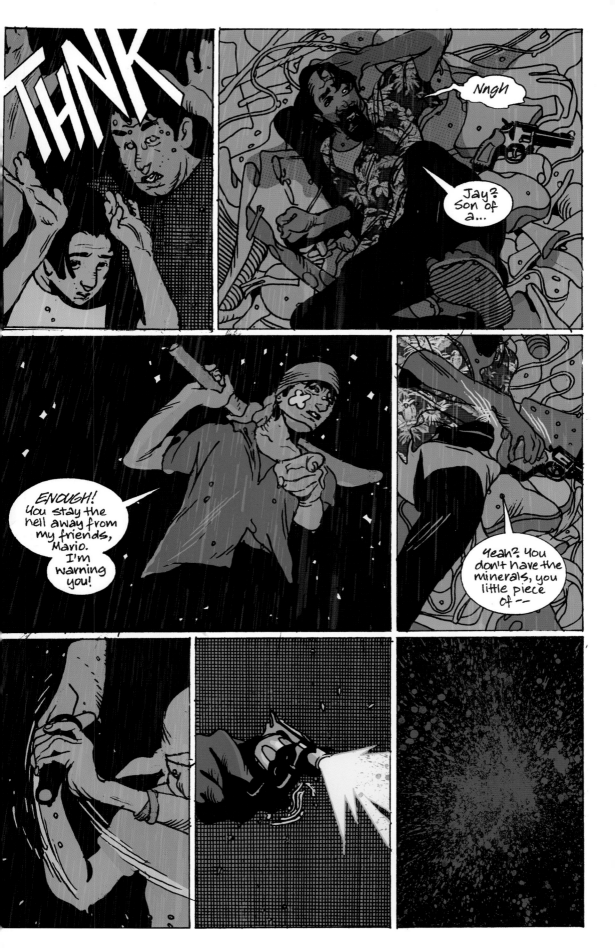

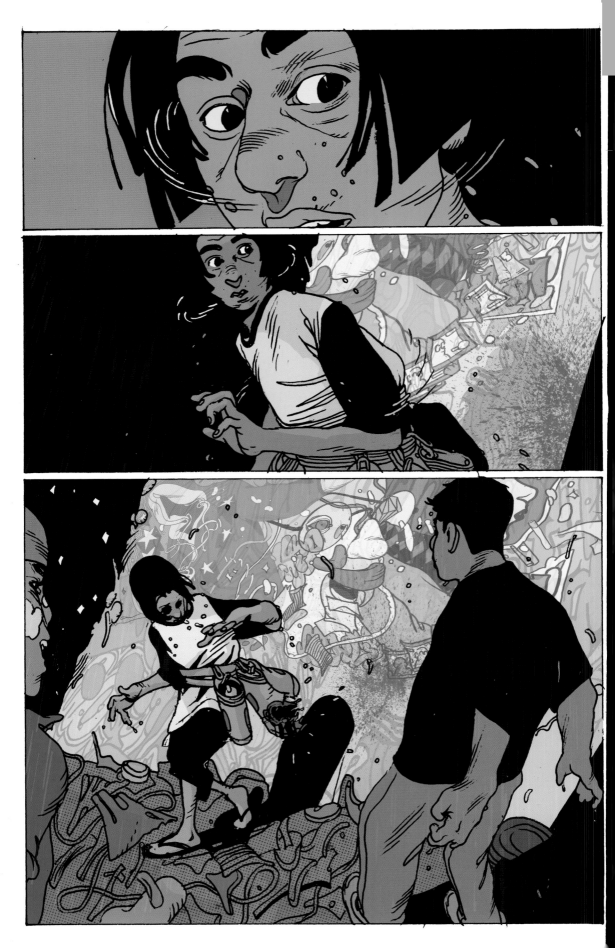

EPILOGUE

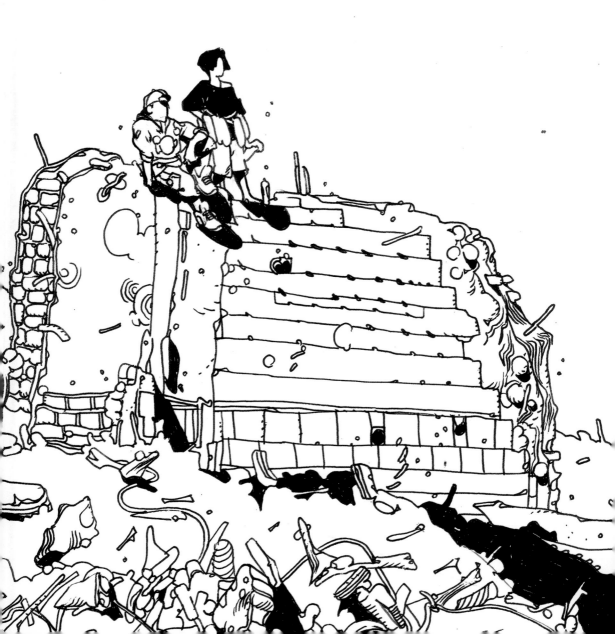

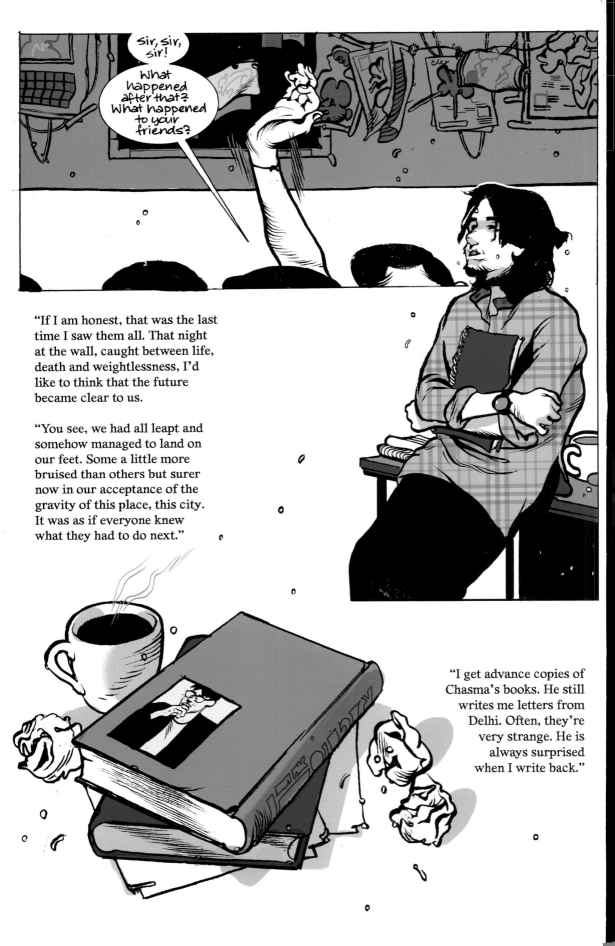

Sir, sir, sir!

What happened after that? What happened to your friends?

"If I am honest, that was the last time I saw them all. That night at the wall, caught between life, death and weightlessness, I'd like to think that the future became clear to us.

"You see, we had all leapt and somehow managed to land on our feet. Some a little more bruised than others but surer now in our acceptance of the gravity of this place, this city. It was as if everyone knew what they had to do next."

"I get advance copies of Chasma's books. He still writes me letters from Delhi. Often, they're very strange. He is always surprised when I write back."

"I think I saw Saira in a commercial for detergent, once. She was smiling, she seemed happy. Then again, everyone seems happy in advertisements. I asked Chasma in a letter once if he had ever written to her.

"'Why would I ruin what we have?' he wrote back to me. I suppose that makes sense."

"And Jay I haven't heard from since. I understand it, of course. He couldn't have possibly stuck around after how he'd stopped Mario. I was taken down to the police station several times after. I was questioned about the events of that night and asked if I knew where Jay was.

"I kept hoping he'd show up, cap flipped backward, that familiar hoody on even in the sweltering heat, saying something that sounded dangerously close to being wise.

"I miss him. And I hope that wherever he is, he is happy and well."

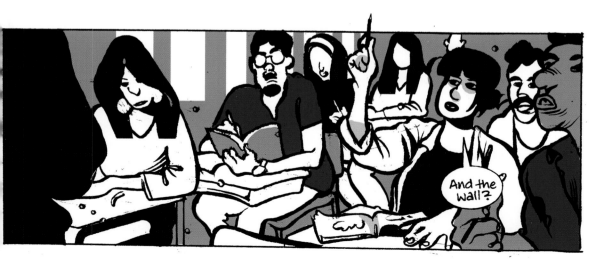

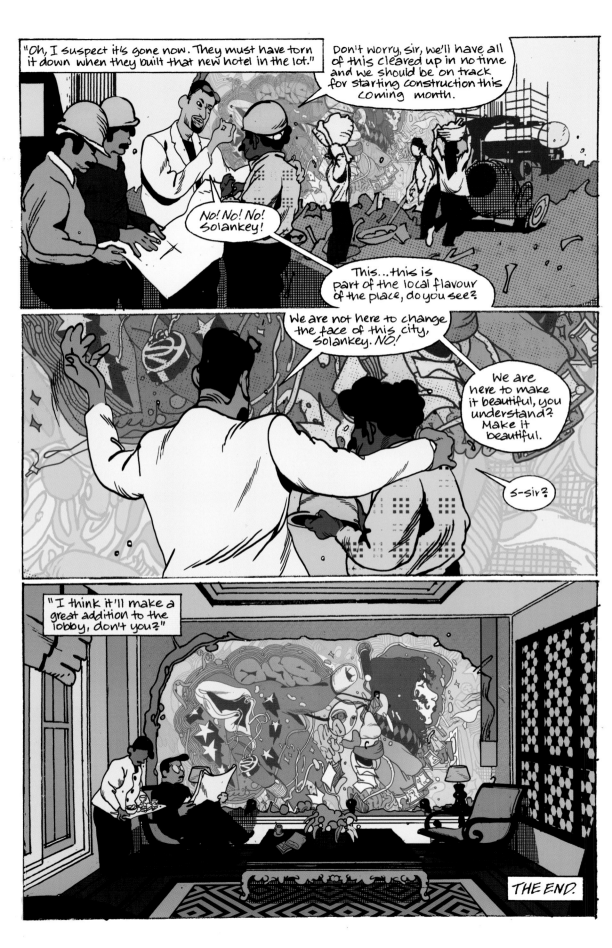

In 1989, I was only a tiny fella. The unruly kid in fourth standard with untucked shirt-tails, ink-stained tie, and ill-fitting shoes. Every afternoon, after school, I'd walk the dusty road home, baked in the sun, stepping on cracks, jumping over gutters, to a place called Brahmin Society. The political undertones of that name were still unknown to me and I only remember it now with fondness, this quadrangle flanked by chawls and old houses; kids playing cricket on a stretch of unpaved ground, sending sixers flying into the temple across the road.

Even in those days it was a place that time had forgotten. As if the rest of the city had moved on and left a little patch behind. Neighbors still evened the land with cow-dung and there were gaps in the stone wall behind the houses that you could jump through and enter a wooded place of ghosts and witches and buried secrets. Boundaries were porous. You were never unwelcome at anyone's home, doors were left unlocked, and there was always company for dinner or movies.

Now, every so often, I'll get someone asking me where do your stories come from? It's a strange question to answer. I don't pretend to know. But if I were to hazard a guess... stories come from these places. Forgotten by time, places and people hidden away from the surface. Every city has them. These alcoves overlooked among the high-rises and six-lane motorways. This is where a city decides where it'll go next, who it'll be in the years to come. Somewhere in those narrow alleys between brick walls and corrugated roofs, a generation of people are writing a story.

I'm just lucky to be looking in.

RAM V, LONDON, 2018

I was eighteen and in the first year of art college at the J.J. Institution of Applied art in Mumbai. I was in Turmoil. Students came from all over India to study at this historic institution of art. And, to my eyes, there were so many who came from quiet and distant places, steeped in the kind of education you get when your ancestral profession has been to create art. I'd lived in Mumbai all my life and no one in my family had ever held the profession of creating art in any kind of esteem.

It was also a time of great learning for me. I discovered bootlegged copies of *Metal Hurlant* and the works of great animators from japan and Europe. I discovered Moebius and Otomo and Tupac. I smoked cigarettes, sat under tin roofs, drinking chai with friends. I stole into the night to paint murals on disapproving walls. I was not very good at it back then.

When Ram sent the script for *Grafity's Wall*, I read the bit where Suresh talks about why he tags walls and I immediately recognized that feeling. You're in conversation with a place that surrounds you, both without and within. A conversation of images created in both defiance and love.

I am not the kind of person to draw influences from what I see around me. But I am nonetheless influenced by this place where I live and where I have grown up. All of my work on some level is in conversation with this city. On paper, canvas or walls.

Perhaps when this book is done, I will go back and try making some graffiti again. Are you Listening?

ANAND RK, MUMBAI, 2018

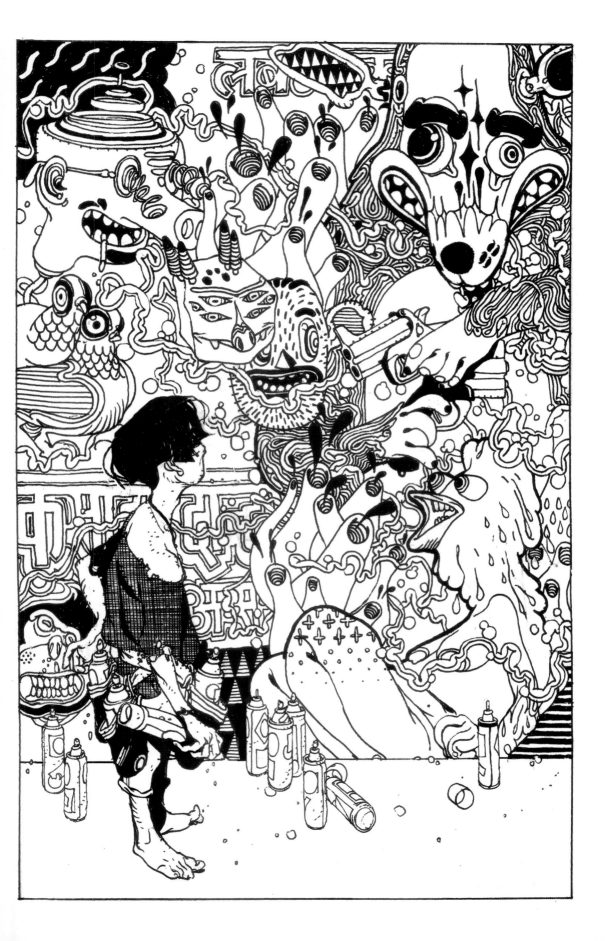

WRITING BETWEEN THE LINES
BY ADITYA BIDIKAR

I hadn't planned to hand-letter a book anytime soon. Honest. I'm only now figuring out how to design a comic-book typeface that doesn't go splat when I use it on a page. Hand-lettering was just something I occasionally practiced so I could feel this imposter syndrome all the cool kids were talking about.

What led here was a brash overstatement that Anand and Ram took at face value (for their own eeeeevil ends). I'd been seeing pages for *Grafity's Wall* coming in, and I asked Anand what he was using to draw the book. "Gel pen on cartridge paper," he said.

"So," I said, "wouldn't it be fun if I lettered the book with a gel pen on cartridge paper?"

** Flash Fact: Cartridge paper is so named because it was originally used to make gun cartridges.*

Everyone thought that it would, in fact, be fun, and decided that was exactly how the book *should* be lettered. I was massively skeptical, but decided to give it a go, always with digital lettering parked outside the door with the engine on.

I did a few tests in both uppercase and mixed case. Uppercase, while adequate, didn't have the loose energy the book needed – specifically my uppercase, which at this time I still drew stiffly with my tongue stuck out and my brow furrowed in concentration because I'd get the spacing disastrously wrong if I didn't. On the other hand, I felt comfortable about my mixed case, which I'd derived from my regular writing style, so I didn't have to force my hand into alien contours as far as possible.

Next, I ran through a few sizes to settle on a size that'd both look good printed and that I could work at. We settled on the 4mm style on the top-left, which looked neat but not too stiff. Here, I ran into my biggest problem. This would require a brief primer on how hand-lettering is done in comics.

The most essential instrument for a hand-letterer is an Ames Lettering Guide, used to draw multiple horizontal lines at set distances with the help of a T-square.

Mixed case lettering involves four elements to do with height: the x-height, ascenders, descenders and line spacing (or leading). The 2:3 scale lets you draw guidelines for the first three elements, while you eyeball the leading.

This looks pleasant enough, as you can see below, and if I were lettering an entire page of pure text, I'd be pretty happy doing it like that. The problem emerges when you try to use this to letter a comic. There's *entirely* too much space between the lines, to the point where it looks ugly.

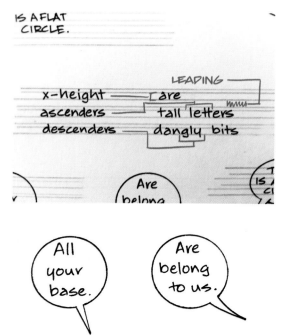

Secondly, Costanza and Cooke use a high x-height to maintain readability while reducing ascenders and descenders (particularly the former) to the bare minimum necessary. Learning to draw shorter, more suggestive descenders like them would improve both readability and elegance.

The rest, Costanza made me realize, was pure skill. The only way to avoid intersecting lines was to draw them so they never touched. The ascenders and descenders would need to go on a careful little dance, one I could *only* do in hand-lettering, because I'd be drawing each and every letter live so it could react to the letters around it. This was my Eureka moment, when I knew I *had* to hand-letter this book and put this into practice.

I went back to my drawing board, and dumped the Ames guide's x-height measure, instead drawing guides the way I used to for uppercase lettering. And thankfully, the research worked, because it looks nice and snug in the balloons themselves.

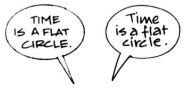

When I letter digitally in mixed case, I first reduce the leading to the lowest possible, and second, I manually adjust line height for lines without ascenders and/or descenders to make the lines flow better within the balloon.

To do that here, I would have to letter 'wrong' on paper and fix all of these digitally, which would be a) time-consuming, and b) a workaround rather than a solution. Also, I wouldn't be able to trust the balloons I drew around the text because the size of the text would change.

I realized I needed to ignore how digital lettering functions, look at the work of my favorite hand-letterers working in mixed case, and try to reverse-engineer it. So that led me to spend a few hours pouring over the work of John Costanza, Gaspar Saladino and Darwyn Cooke.

You might say this was a lot of work to put into doing one book, when I could easily have done it a lot quicker digitally. But this, for me, is where my work comes alive, where I'm tackling something new and exciting with people I enjoy working with who let me experiment. This is where I can come out and play with my friends. My hands are dirty with ink stains and my desk looks like a finger-painted canvas – and it's awesome! ·

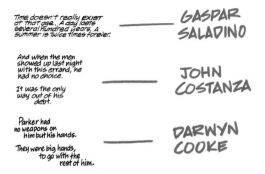

First, I noticed that in all three, the descender of one line and the ascenders of the next occupy the same vertical space. There is no traditional 'leading'. Which meant I'd need to get rid of my 2:3 ratio.

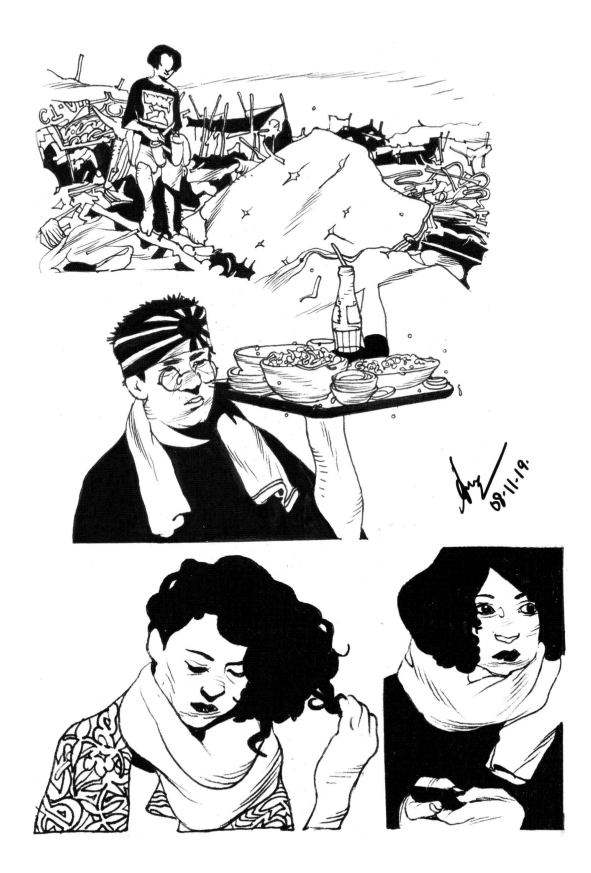

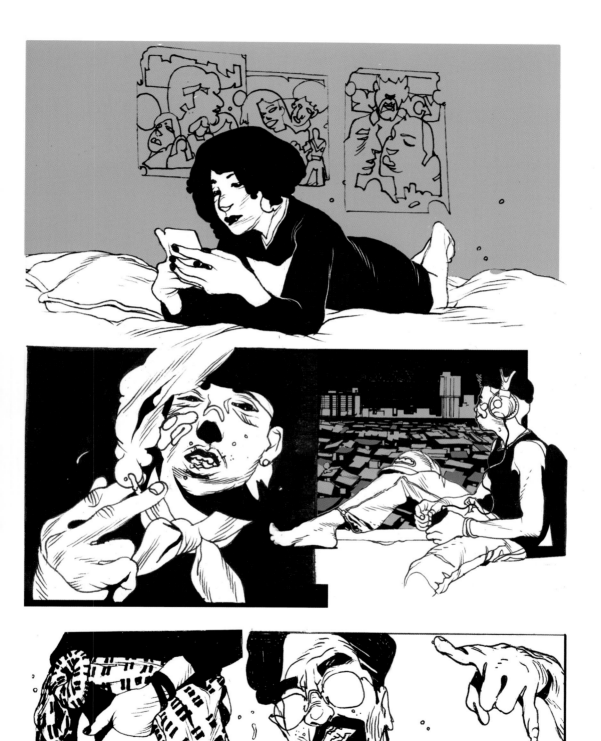

23·08·19.

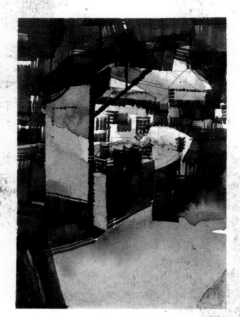
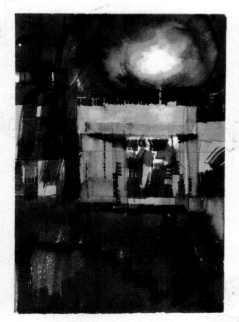
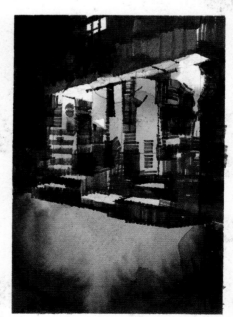

Wadda
15-07-19.

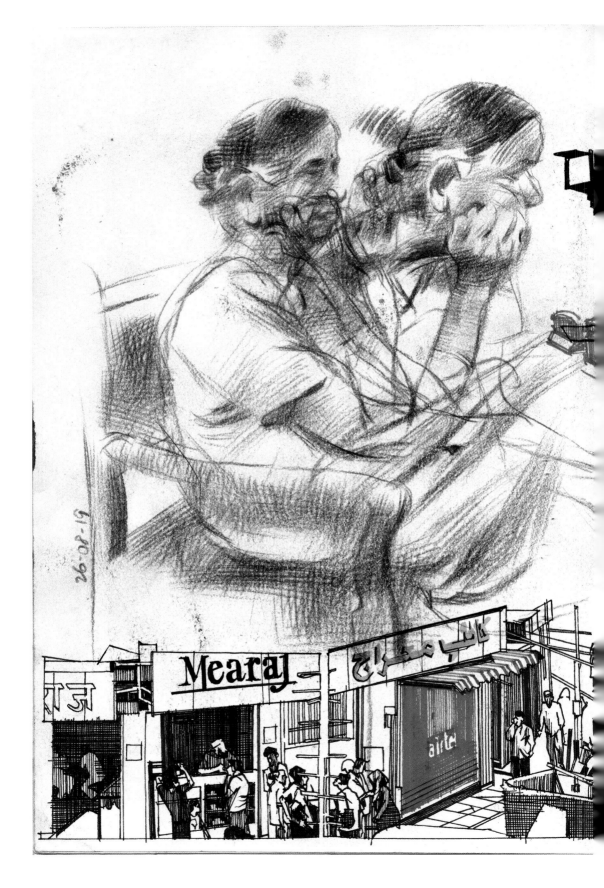

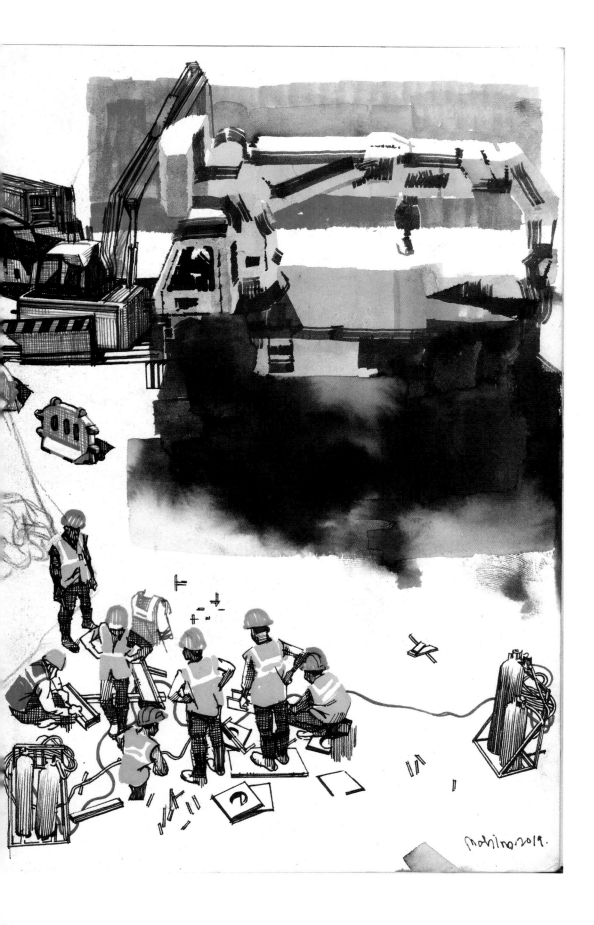

RAM V is an award–winning author and creator of comics & graphic novels such as *Black Mumba*, *Paradiso*, and *These Savage Shores*. His short stories and comics have appeared in various publications. Since self-publishing his first book in 2016, he's also gone on to write for iconic characters at DC Comics and Marvel.

Conspirator and trouble-maker at White Noise Studio comics collective, Ram currently lives in London—dog person, doodles, argumentative melancholic.

ANAND RK is an illustrator and comic book artist who lives and works in the Indian city of Mumbai. His work includes an eclectic mix of illustration, painting, personal projects and comics. He is currently drawing his second book while writing and juggling half a dozen personal projects on the side.

ADITYA BIDIKAR is an award-winning letterer for comics like *Isola*, *Little Bird*, *These Savage Shores*, *Hellblazer*, and many more. He is also occasionally a writer and an editor.

He lives in India surrounded by comics. Cat person, but makes an exception for Ram's dog.

Colorist **JASON WORDIE** hails from Canada. He has done work for Image, Dark Horse, Boom!, Titan, Aftershock and Vault. Some of his works include *God Country*, *Protector*, *Abbott*, *Wasted Space*, *Resonant*, and *Out of the Blue*. You can follow Jason on twitter @WordieJason